Children *of the* Gilded Era

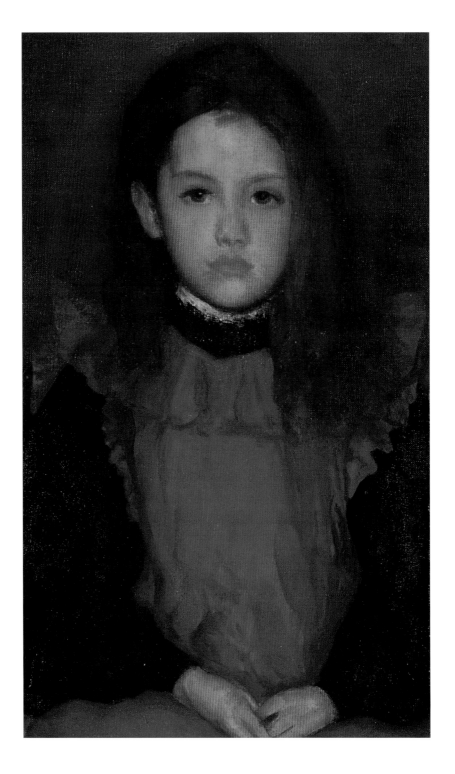

Children *of the* Gilded Era

Portraits by Sargent, Renoir, Cassatt, and their Contemporaries

Barbara Dayer Gallati

MERRELL

LONDON · NEW YORK

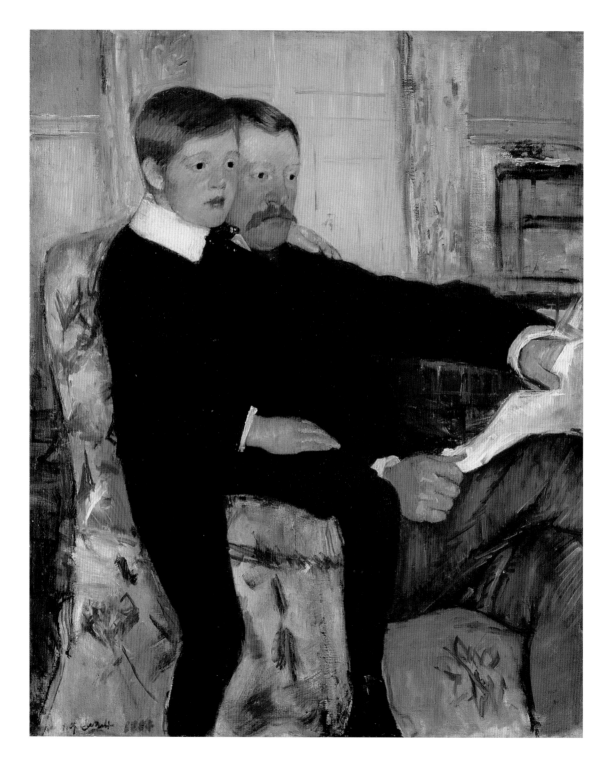

Contents

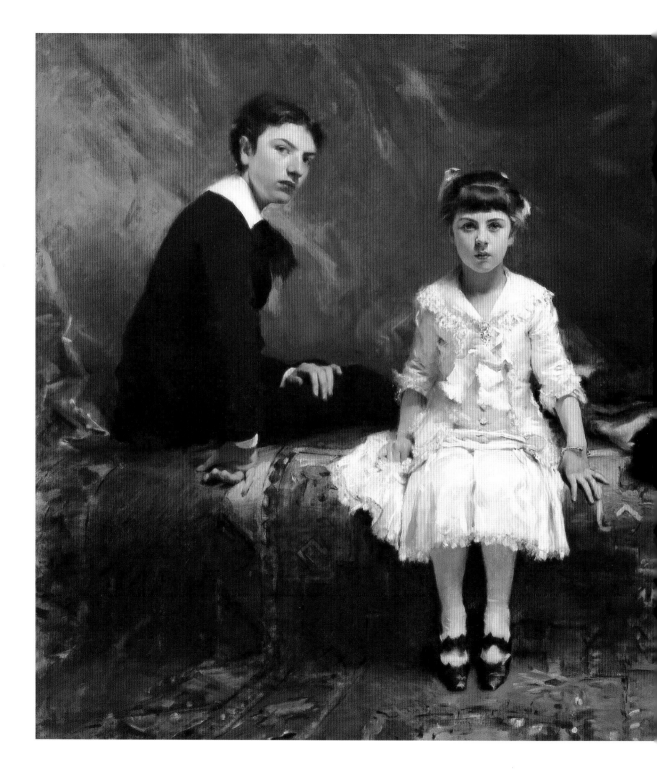

Portraits of Innocence
and Individuality

The end of the nineteenth century is often called the Gilded Age. Indeed, it was an era that witnessed the accumulation of great fortunes and the almost feverish amassing of goods and art to fill the palatial homes that those fortunes built. Ironically, the term was born with the 1873 publication of the novel *The Gilded Age: A Tale of Today*, a social satire co-authored by Mark Twain and Charles Dudley Warner, which describes the effects (both positive and

JOHN SINGER SARGENT
Edouard and Marie-Louise Pailleron, 1881
Sargent (American, 1856–1925) was just beginning his career when he painted Edouard and Marie-Louise, the children of the Parisian essayist and playwright Edouard Pailleron. Perhaps encouraged by Pailleron's status in the theatrical community, Sargent adopted uncommonly dramatic means to portray these youngsters, such as radical lighting, rich, deep colors, exotic studio props, and the suggestion of psychological distance between brother and sister.

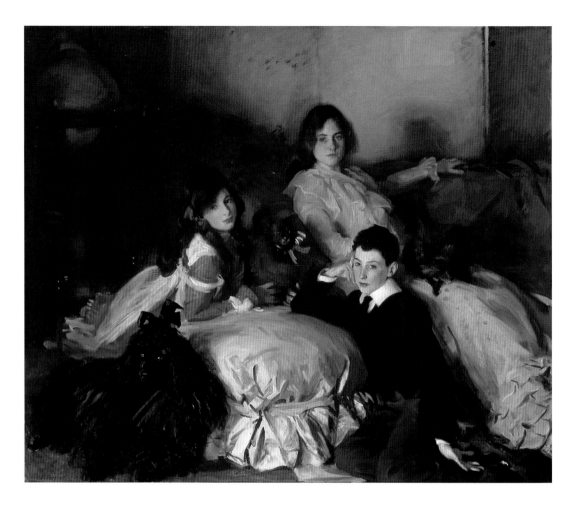

JOHN SINGER SARGENT
*Essie, Ruby, and Ferdinand, Children
of Asher Wertheimer*, 1902
Sargent portrayed three of the children
of his friend and patron the London art
dealer Asher Wertheimer in a luxurious
domestic environment. Their poses and
expressions suggest that they already
possess a level of sophistication and
self-confidence rarely associated with
childhood, worldly sensibilities alluded
to by the globe at the upper left.

negative) of the rampant economic speculation that fueled the hopes
and dreams of Americans in the decades following the Civil War.
The phrase "Gilded Age" soon entered common usage and now
refers generally to this pivotal period in the histories of the United
States and Europe, a period defined by the often extreme economic,
social, and political changes wrought by wealth and its pursuit.

Family life was transformed at this time and, as many social
historians have observed, children became the center of the family's

existence. As living symbols of the family's continuation, children were seen to deserve and require special protection and education, all in preparation for their futures as inheritors and perpetuators of the family's legacy—material, genetic, and spiritual. Not surprisingly, the impact of childhood's newly attained cultural status is revealed in the art of the most revered painters and sculptors of the Gilded Age. And, although children's portraits were commonly commissioned throughout the century, few can be said to have

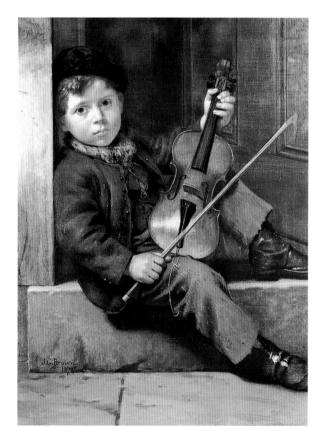

JOHN GEORGE BROWN
The Boy Violinist, 1874
During the 1870s Brown (American, 1831–1913) exhibited nearly a dozen works featuring young children who had been brought to the United States (frequently under false promises to their poor European parents) and forced to perform on the streets, only to hand over their meager earnings to the padrone who was nominally their guardian. Brown's sympathetic approach to this world-weary little boy parallels the public response to the plight of these children, which resulted in a number of social reforms.

attracted the same intense critical scrutiny and praise as most of the works included in this volume. John Singer Sargent, for example, gained significant attention for his display of *Essie, Ruby, and Ferdinand, Children of Asher Wertheimer* (see page 8) at the New Gallery in 1902, a year the London press declared his "triumph." Large and lusciously painted, the triple portrait vividly demonstrated that the subject of childhood had been assumed into the highest levels of contemporary artistic production.

Most children, of course, were not as fortunate as Sargent's young sitters and, while this fact was also reflected in the arts of the period (see page 9), few artists truthfully depicted the impoverished youngsters who were highly visible on the urban streets of Europe and the United States. In part, the social transformation of childhood during the Gilded Age was the result of philanthropic endeavors aimed at reducing the hardships experienced by children. Social reformers campaigned for new labor and education laws, the implementation of which essentially extended the length of childhood (thus redefining the child in the context of both the family and the state). The child also became the focus of marketing strategies, with specialized goods developed and promoted for the "small" consumer. The Gilded Age also ushered in the child study movement that drew on multiple disciplines—among them, sociology, education, medicine, and psychology—to determine the exact nature of childhood.

The portraits of children reproduced in this book reflect the shift in attitudes to childhood that occurred during the Gilded Age.

JAMES MCNEILL WHISTLER
Harmony in Grey and Green:
Miss Cicely Alexander, c. 1872–3
Cicely was the daughter of a London banker and art collector. According to Whistler (American, 1834–1903), the painting required at least seventy sittings—a grueling set of sessions that the girl remembered vividly as having frequently brought her to tears.

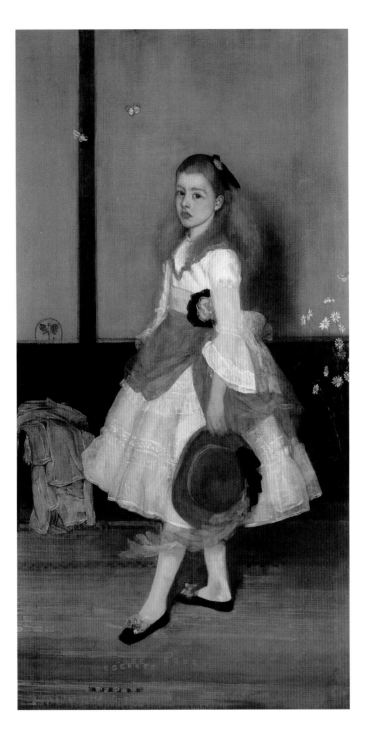

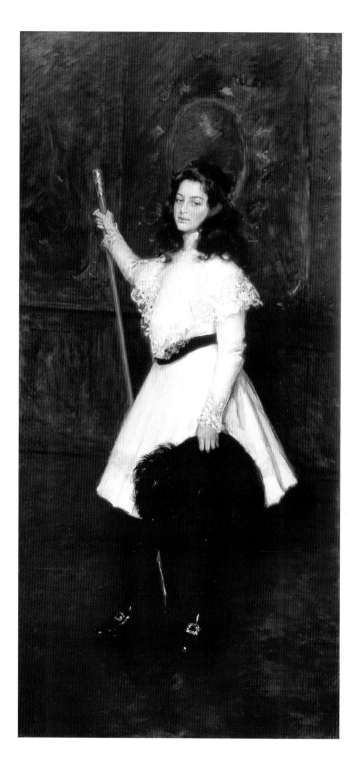

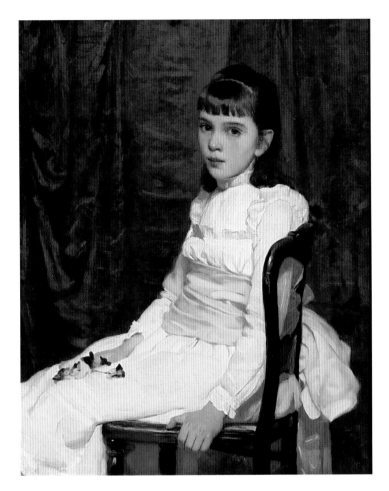

As representations of actual people, they show only one side of the larger cultural picture since the children they portray belonged, for the most part, to families who could afford to commission works of art or were the sons and daughters of the artists and their friends. Regardless of the interpretations we may form in looking at them today, it is necessary to see these portraits first and foremost as

works that were intended both to preserve the likeness of a precious child and to function as objects of aesthetic value.

Graphic testimony to the revised importance of child imagery in the fine arts is provided in the art of the cantankerous and determined aesthete James McNeill Whistler. Interspersed among his more numerous landscape nocturnes and portraits of fashionable adults are masterful and compelling paintings of children that were also crucial milestones in his career. No survey of Whistler's art would be complete without reference to *Harmony in Grey and Green: Miss Cicely Alexander* (see page 11), a marvelous *japoniste* essay in subtle tonalities in which the painter's signature butterfly colophon is repeated in the two yellow butterflies fluttering above the girl's head, placed there as if to activate the traditional symbolism of the insect for the fleeting nature of life and, especially, the brevity of childhood. Nineteenth-century critics responded uneasily to Cicely's somber expression, finding it out of keeping with the more common, sentimentalized representations of cheerful children then favored by Victorian audiences. Whistler, however, consistently countered such conventional attitudes and continued to portray his child subjects as serious, almost melancholy individuals (see pages 2 and 96) and his influence is felt in the art of many of his younger contemporaries (see pages 12–13).

Sargent challenged similar stereotypes even more directly, particularly with his portrait of Edouard and Marie-Louise Pailleron and the monumental *Daughters of Edward Darley Boit*

JOHN SINGER SARGENT
The Daughters of Edward Darley Boit, 1882
Critics were staggered by Sargent's unconventional presentation of the daughters of a wealthy Boston lawyer-turned-painter. One writer complained, "All this is very well as showing the artist's clever manipulation of 'effects,' but what in the world has it to do with portraiture?" Another observed, "The canvas is large beyond precedent, considering that the portraits are those, not of four reverend signors, but of four little girls."

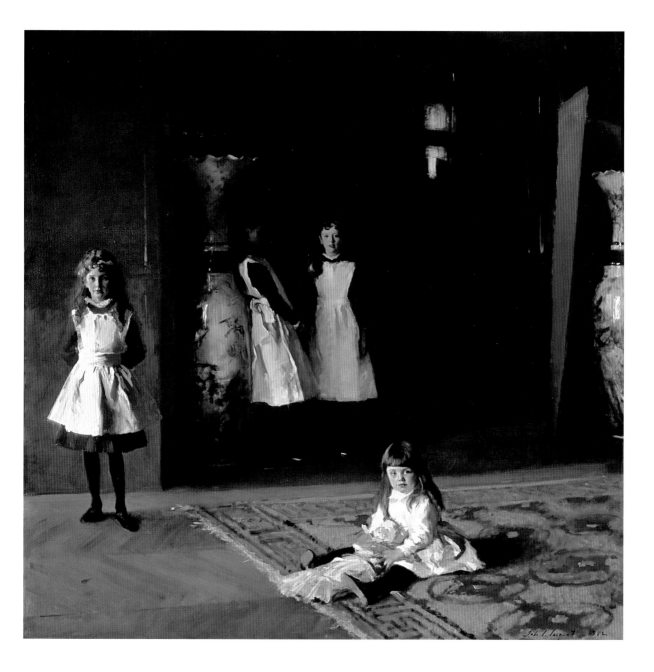

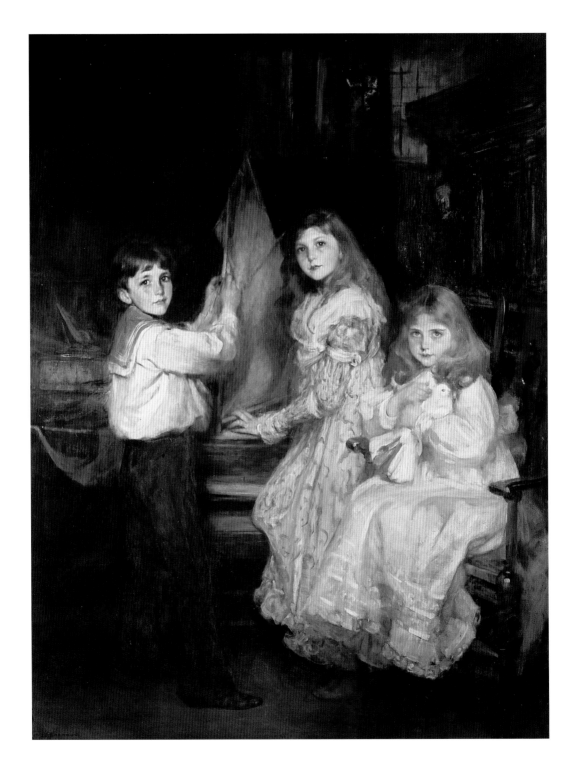

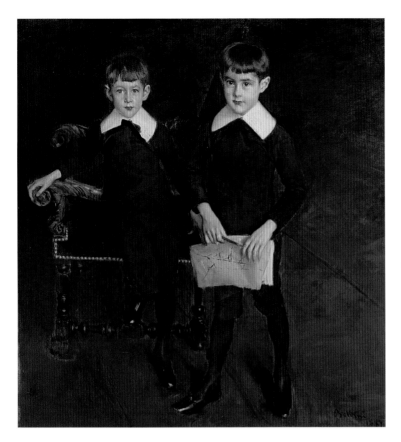

(see pages 6–7, 15), both of which contributed to the formation of his reputation as a portrait painter when they were shown at the Paris Salon in 1881 and 1883, respectively. Among other things, the latter work defied the tenets of portraiture by obscuring the faces of the two older girls, by arranging the children in a relatively empty, inhospitable space, and by devoting such a large canvas to the "minor" subject-matter of childhood. The influence of the Boit canvas can be traced in a variety of works (see opposite and above), but none achieved the discomforting tensions that prevail in Sargent's image of the four sisters.

(Opposite)

JAMES JEBUSA SHANNON
Molly, Tim and Dorothy, the Children of James Younger, c. 1898
The large scale and view into the deep space of a darkened interior in Shannon's portrait of three children are reminders of the lingering impact of Sargent's portrait of the Boit sisters (see page 15). Shannon (Anglo-American, 1862–1923), however, emphasized the charm and playfulness of his little subjects, a quality that led one reviewer to describe the work as "dexterous, dainty, and of assured excellence."

GIOVANNI BOLDINI
Luis and Pedro Subercaseaux, 1887
Pedro and Luis were the elder children of the Chilean diplomat Ramón Subercaseaux and his wife, Amalia Errazuriz (whose portraits Sargent had painted in Paris in 1880–81). Boldini's portrait of the boys (which recalls Sargent's portrait of the Boit sisters) reflects the sophisticated cosmopolitan tastes of the family and also the strong connections between Sargent and Boldini (Italian, 1842–1931), at a time when the two men were establishing themselves in the international portrait market.

17

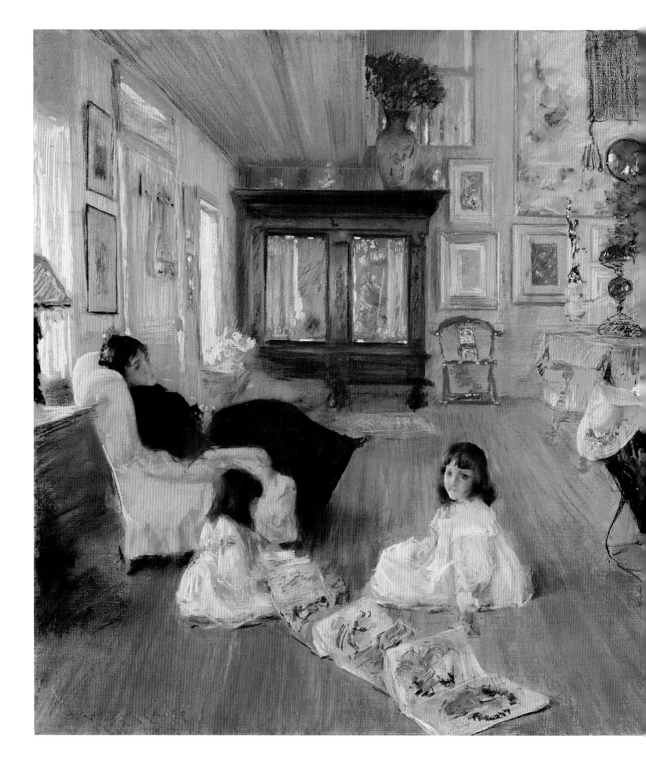

The Center of Attention

Whereas Whistler and Sargent often broke from established ways of depicting youngsters, many artists continued to rely on the more traditional iconography of the family to portray young sitters. Nonetheless, their imagery vividly communicated the child's newly elevated importance within the family circle. George de Forest Brush's *The Portrait* (see page 20) is remarkable for its capacity to merge the complex issues of family life, portraiture, and Brush's professional identity. The painting shows the artist drawing a

WILLIAM MERRITT CHASE
Hall at Shinnecock, 1892
Alice, Chase's eldest child, gazes out of the pictorial space, drawing the viewer into the deep recesses of the main hall of the artist's summer home and studio in Shinnecock, Long Island. Chase frequently included his family in important works—both genre and portrait subjects—that are now interpreted as his personal statements about the unified nature of his private and professional life.

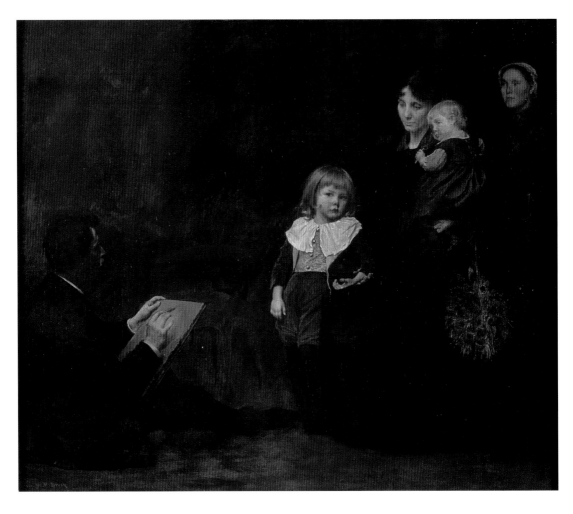

GEORGE DE FOREST BRUSH
The Portrait, 1892
Although this is a family portrait, Brush (American, 1855–1941) directs the viewer's attention to his identity as an artist. When it was exhibited at the Society of American Artists in 1892, reviewers saw it as a sign of a new direction in Brush's art; previously known for his paintings of Native Americans, Brush ultimately earned the title of the "master of babyhood."

likeness of his son Gerome, who anchors the composition in terms of his placement and the mechanics of lighting. Gerome is supported (and perhaps restrained) by his mother, who also holds her younger child Nancy—a motif that presages Brush's later concentration on mother-and-child subjects. Brush's inclusion of himself in the painting is unusual since most artists of the time chose to assert their identities in family portraits in less overt ways.

William Merritt Chase, for instance, appears as a reflection in the mirrored panel of a chest at the end of the large hall in his home and studio at Shinnecock, Long Island, leaving the viewer to focus primarily on his wife and daughters in the foreground (see pages 18–19). The English painter Solomon J. Solomon used another strategy in an elaborately detailed portrait of his wife and children by using the pointing gesture of his centrally placed infant daughter to call attention to his identity as the creator of both family and painting (below). Alternatively, the French Impressionist Pierre-Auguste Renoir's role as paterfamilias is unequivocally declared in his massive *The Artist's Family* (see page 21), a canvas that implies

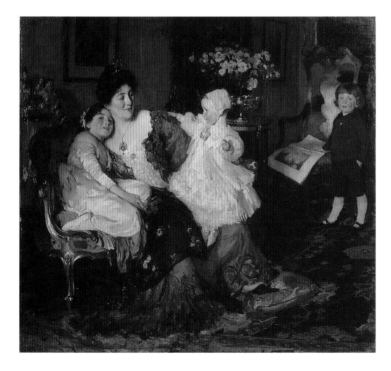

SOLOMON J. SOLOMON
A Family Group: The Artist's Wife and Children: Papa Painting!, 1905
This affectionate portrayal of his wife and children by Solomon (English, 1860–1927), in their home at Hyde Park Gate, London, not only provided his audiences with a fine example of his talents as a painter but also advertised the artist as a devoted family man.

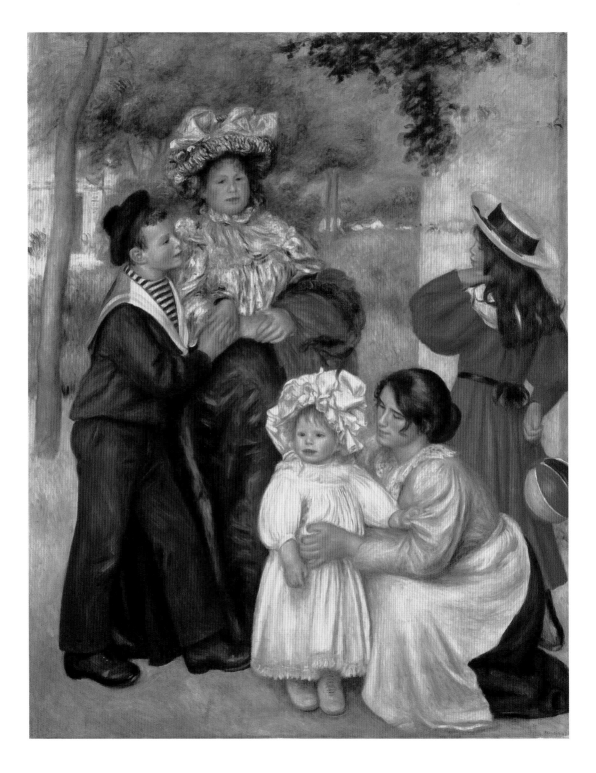

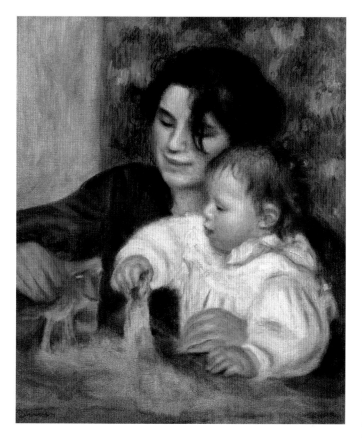

(Opposite)
PIERRE-AUGUSTE RENOIR
The Artist's Family, 1896
Renoir's (French, 1841–1919) massive canvas (showing his wife, Aline, sons Pierre and Jean, a young neighbor girl, and Gabrielle Renard, the family nurse and housekeeper, and Renoir's model) held a central place in the 1896 Exposition Renoir at Durand-Ruel's Paris gallery. The largest portrait in the artist's oeuvre, the painting has been interpreted as a sign of Renoir's belated acceptance of bourgeois family life.

PIERRE-AUGUSTE RENOIR
Gabrielle and Jean, 1895
Renoir's loving fascination with the growth and behavior of his young son Jean is documented by the many drawings, pastels, and paintings in which the youngster appears even before he turned two years old. Here the boy is tenderly supported by his nurse, Gabrielle, his attention taken by the toy bull she introduces into the scene of play, while he grasps a figurine in response to her gesture.

the artist's presence not only through the unmistakable workings of his brush but also because his family was frequently the subject of his art and, therefore, familiar to his audience (above). Such family portraits, despite their nuanced differences, underscore the general unity among Gilded Age artists in conveying their own rising status in society through the imagery of family and, within that framework, featuring their offspring as both the inspiration for and the chief beneficiaries of their painter father's professional success.

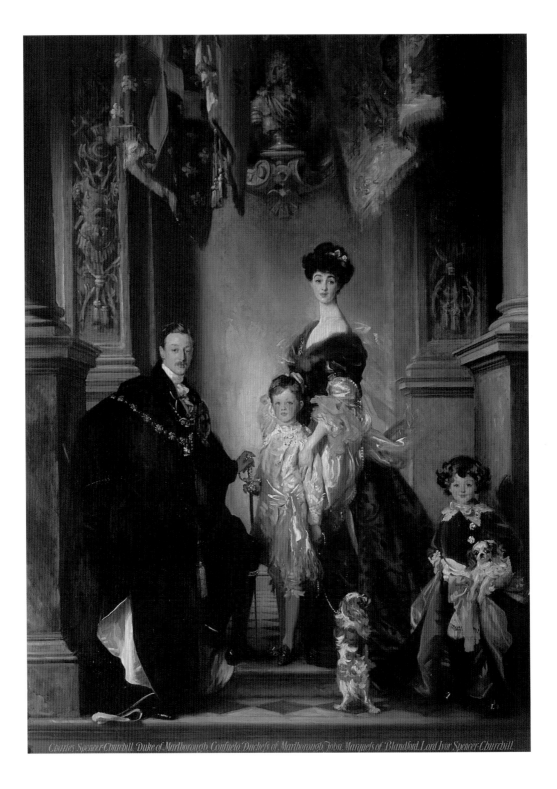

Charles Spencer-Churchill, Duke of Marlborough, Consuelo, Duchess of Marlborough, John, Marquess of Blandford, Lord Ivor Spencer-Churchill.

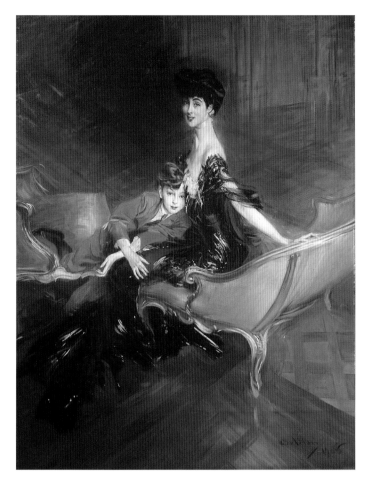

(Opposite)

JOHN SINGER SARGENT
*The Family of the 9th Duke
of Marlborough*, 1905
Commissioned to hang at Blenheim
Palace in the vicinity of the famous
portrait of the 4th duke and his family
painted by Joshua Reynolds in
1777–78, Sargent's operatically scaled
canvas clearly focuses on the theme
of dynastic continuity. John, Marquess
of Blandford, stands at the center of
the composition to indicate that he is
first in line to inherit family titles and
property, while his younger brother
Ivor stands to the side.

GIOVANNI BOLDINI
*Consuelo, Duchess of Marlborough
and her Son Lord Ivor Spencer-
Churchill*, 1906
Boldini had begged to paint the
duchess and was granted his wish
with this canvas, which was begun
in his Paris studio. Finding the
likeness accurate, the duchess decided
to acquire it, provided that her younger
son was included in the portrait—
a decision that may be connected
to the fact that the duke and duchess
officially separated that year with the
unusual agreement of joint custody
of their boys.

Examples of entire family groups for the period, however, are extraordinarily rare, a fact that perhaps reflects the growing division between the domestic and business spheres occupied by the middle and upper classes; men simply did not have the time (or inclination) to pose in the context of the increasingly "feminized" domain of the home. Sargent's magisterial *The Family of the 9th*

25

Duke of Marlborough (see page 24) and Lawrence Alma-Tadema's intimate *Portrait of Aimé-Jules Dalou with his Wife and Daughter* (opposite) represent the polarities within this narrow category of family portraits. The first, a commissioned work, is literally an emblem of the Duke of Marlborough's aristocratic history and positions the elder son as the designated inheritor of that long tradition, while the younger son is relegated to a space that places him conceptually outside the family's patrimonial line of descent. At the same time, the painting suggests the tensions between the duke and duchess, whose marriage was arranged to reinforce the dynastic foundations of the Marlboroughs with the fortune of the American Vanderbilts and whose principal remaining connection was the son who stands at the center of the composition. Other portraits commissioned by Marlborough family members present radically different impressions of them as personalities, mainly because the works were desired for less official, programmatic purposes (see page 25).

In contrast to the operatic grandeur of Sargent's Marlborough canvas, the small portrait of the family of the sculptor Dalou (a gift from Alma-Tadema to Dalou, documenting their friendship) generates the impression of genuine emotional warmth, a sensibility introduced mainly through the tightly compressed space, which requires their bodies to overlap in order to "fit" within the confines of the small panel. Dalou's head is slightly cropped, possibly to emphasize the dominant role of his wife, Irma, within their household. Indeed, it is she who occupies the greater part of the

LAWRENCE ALMA-TADEMA
Portrait of Aimé-Jules Dalou with his Wife and Daughter, 1876
The close emotional connections and bourgeois respectability of the French sculptor Dalou and his family are underscored by this intensely compressed composition of Alma-Tadema (British, 1836–1912). The faces of Dalou and his wife seem to merge, perhaps to suggest their mutual pride in the child who anchors the composition, just as she doubtless provided the focus for their lives.

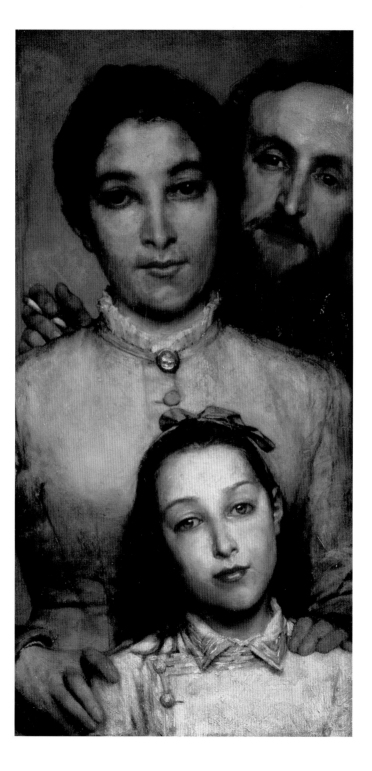

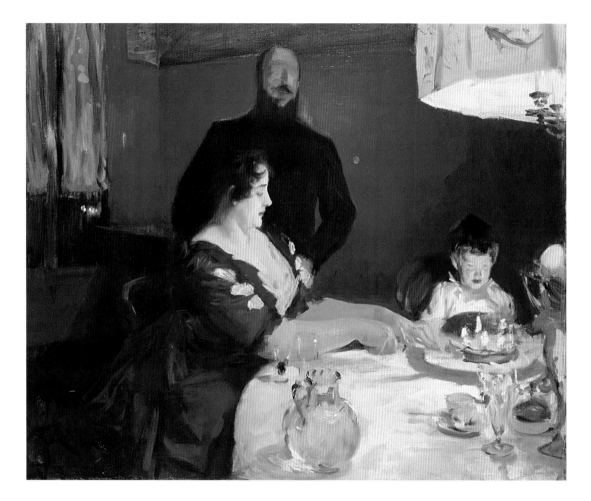

composition and protectively rests her hand on her daughter's shoulder. Nonetheless, the family is united by their gazes, for their eyes fix on the same spot outside the pictorial space. Alma-Tadema may also have intended this family portrait to honor the work of his fellow artist, for Dalou was then noted for his tender treatments of the mother-and-child theme (see page 30).

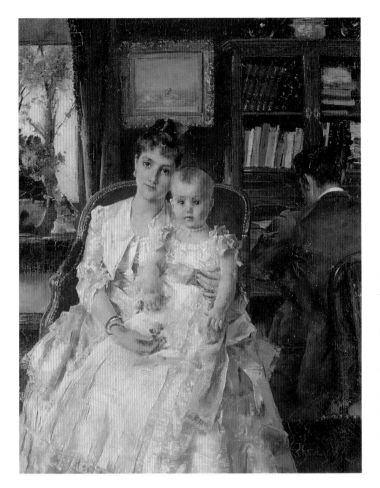

JOHN SINGER SARGENT
The Birthday Party, *c.* 1885
This scene of an intimate family
gathering shows the French painter
Albert Besnard and his wife, the
sculptor Charlotte Dubray Besnard,
celebrating the birthday of their eldest
child, Robert. The brilliant light
illuminating Robert's face heightens
our experience of his anticipation as he
waits for the slice of cake his mother
is about to serve him.

ALFRED STEVENS
Tous les Bonheurs: Scène Familiale,
c. 1880
Stevens (Belgian, 1823–1906), who
spent most of his career in Paris,
often concentrated on pleasant scenes
of bourgeois domesticity. Stable and
virtuous family life was considered
essential for the nation's well-being, a
belief transmitted here in the Madonna-
like treatment of the mother and infant
and the father tending to business at
his desk in the background.

Hints of the growing distance between fathers and children in
the pattern of daily life are found in a number of works in which
the figure of the father is placed on the periphery of family activity
(opposite, above). Only rarely did artists feature children in the
company of men, and these works, apart from aesthetic matters, are
striking for that very reason (see pages 4, 96 and opposite). Edgar

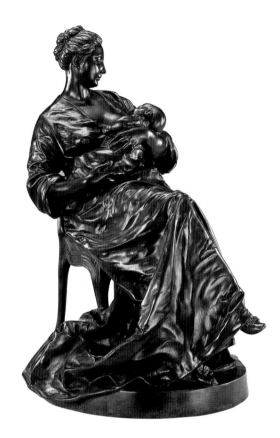

Degas powerfully captured the emotional divide between the
elderly bachelor Henri de Gas (the artist's uncle) and his nine-year-
old ward Aurora Lucia (Lucie), the orphaned daughter of his
brother (see page 32). The double portrait, executed shortly after
the girl entered her uncle's care, gives visual expression to the
awkward relationship that family tragedies had imposed on them.
There are few signs of physical or emotional connection; the uncle
looks up from his newspaper (a motif often interpreted as a symbol
of masculine concerns with the outer world), as if resigned to the

irony of the situation in which he finds himself. Lucie, still dressed in mourning clothes, projects her sadness with a similarly aimed look that suggests that, while her material needs are met, the emotional comfort she requires may not be found in the uncle whose chair she tentatively grasps for support. Degas also inserted a similar sensibility of disconnectedness in *Place de la Concorde, Paris* (see page 33), but in this instance the element of psychological detachment may be more appropriately taken as a comment on the effects of modern urban life.

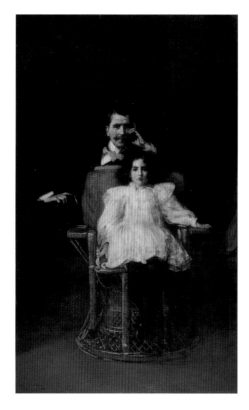

JOHN LAVERY
Father and Daughter, 1900
Although Lavery's daughter frequently appears in his work, this double portrait of father and daughter is extraordinarily rare for the period, when paternal relationships were seldom recorded in portraits. Eileen is seated as if she were a little princess, her status attributable to the casually authoritative figure of Lavery (Scottish, 1856–1951), whose position in the background suggests his proprietary, but distanced, relationship with her in day-to-day life.

EDGAR DEGAS
Uncle and Niece (Henri de Gas and his Niece Lucie de Gas), c. 1876
The emotional atmosphere with which Degas (French, 1834–1917) surrounds his sitters (his own uncle and cousin Lucie) is suffused with ambivalence, perhaps reflecting his personal understanding of the sadness that had entered the child's life and that of the elderly man, who became her guardian in 1875. Although the two are united through their respective gazes, which seem to focus on a single source of interruption, Lucie's figure is isolated against a rectangular golden ground as if to indicate the child's lonely existence in the care of her bachelor uncle.

(Opposite)
EDGAR DEGAS
Place de la Concorde, Paris (Vicomte Lepic and His Daughters), 1875
Although the identities of the figures are known and their faces clearly depicted, some modern scholars have questioned whether this painting was meant to be a portrait in the technical sense of the word. Instead, the artist's friend the vicomte, his children Eylau and Janine, their dog Albreckt, and the passer-by on the left (another friend, Ludovic Halévy) seem to have become actors in this evocation of the urban space that gives the painting its title.

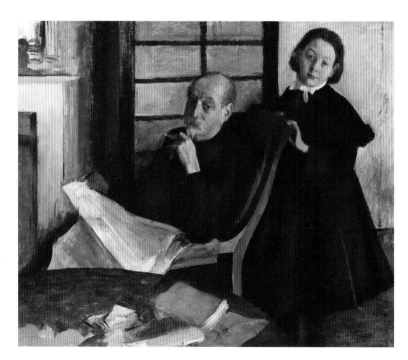

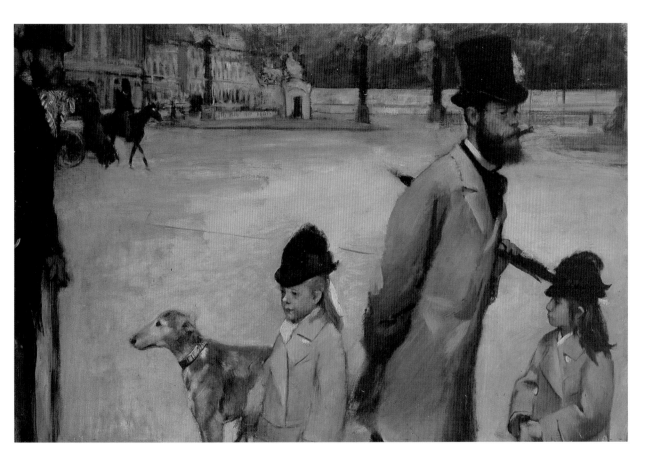

33

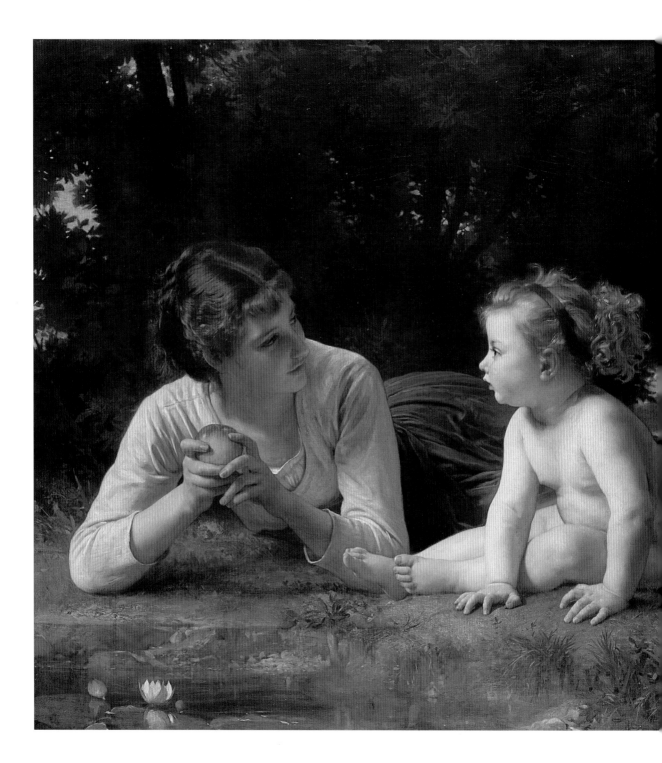

The First Portrait

Infants and toddlers are found in great number in late nineteenth-century art and often functioned as the narrative focal points in works of both critical and popular appeal (left, and pages 36–37). However, portraits of very young children usually held little interest for any but the most doting of parents, for whom the readily available photographic process most often filled the bill (see pages 38–39). Even the modestly successful English painter

WILLIAM-ADOLPHE BOUGUEREAU
Temptation, 1880
Bouguereau (French, 1825–1905), a popular and highly skilled painter, was especially admired for his tender images of peasant children—young shepherdesses and infants poised as allegories of Christian purity. Here a veiled allusion to the theme of Eve in the Garden of Eden provides the excuse for this charming episode between a young woman and an infant girl, which playfully foreshadows the baby's future as a woman.

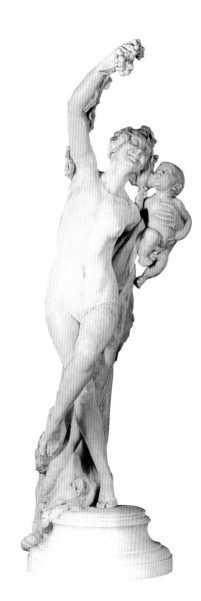

William Quiller Orchardson failed to satisfy the critics with his *Master Baby* (see page 40), a portrait of his infant son and wife, largely because neither baby nor mother met the standard criteria for prettiness or sentiment. Orchardson's painting, although exhibiting formal echoes of Aestheticism, is essentially rooted in a realistic approach that ran counter to the saccharine idealizations of infancy and motherhood that dominated public exhibitions in Europe and the United States in the 1880s. Ironically, the painting's unpopularity with the critics may be attributed to the general critical opinion that the subject of babyhood did not lend itself well to high art. By the mid-1880s English reviewers were writing about the "baby disease" manifested in the galleries across the land. Thus Orchardson's uncommonly large canvas, while it did not idealize its sitters, took what was becoming a hackneyed subject and gave it unparalleled proportions. In contrast, Chase's *The First Portrait* (see page 41), a painting of his wife and first child, Alice, was greeted warmly by critics, most likely because its dark palette mediated the sweetness of the maternal theme and aligned the work as a whole with progressive aesthetic practices.

In the context of infant subject-matter, *Baby at Play* (see page 42), by Thomas Eakins, holds a unique place among the hundreds of images of cheerful, burbling babies that gave critics pause in assessing the direction of artistic and public taste. The painting, a portrait of the artist's two-year-old niece Ella Crowell, reflects Eakins's strong allegiance to realism and also indicates

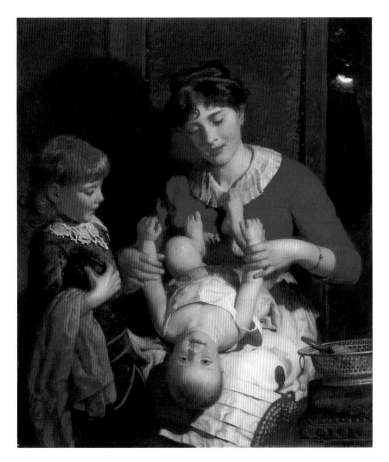

(Opposite)

FREDERICK MACMONNIES
Bacchante, 1905
MacMonnies (American, 1863–1937)
first addressed the mythological theme
of an ecstatic Bacchante holding an
infant aloft in 1893 and continued to
create variations of it into the twentieth
century. Although the works were
consistently greeted with positive
acclaim within the international
art world, conservative Americans
despaired of the woman's nudity.
No one, however, could dispute
the sensitivity of this portrayal by
MacMonnies of infant wonder.

SEYMOUR JOSEPH GUY
See Saw Margery Daw, 1884
A master of academic technique,
Guy (American, 1824–1910)
specialized in genre paintings
whose warm domestic scenes often
charmed American audiences, but
sometimes caused reviewers to bristle
at his sentimentalized depictions
of childhood.

SARONY'S IMPERIAL PORTRAITS,
NEW YORK
*John Claflin Southwick with his
Daughter Susie Kent Southwick,*
c. 1874
Because they were readily obtainable
and inexpensive, most families—
wealthy or not—relied on photographs
to record a child's swiftly changing
appearance. Susie Kent Southwick,
whose oil portrait by Wood is also
reproduced (opposite), seems to have
mastered the art of posing to the extent
that she, more than her father, registers
as a memorable personality.

that his methods in creating this portrait may have been shaped by the burgeoning science of child study. Although the image contains many of the formulaic elements displayed in other contemporary infant subjects—an attractive, nicely dressed child bathed in sunlight and surrounded by toys—the painting exerts a formal weight by virtue of vivid color contrasts, dramatic lighting, large scale, and the dynamic geometries that underlie the structure of its composition. Perhaps a more appropriate title for the canvas would be *Baby at Work*, for Eakins presents Ella in a moment

of intensely focused activity that implies the coordination of mental and motor skills beyond those required to play with either the doll or the horse-and-cart, which she ignores. Working at a time when developmental psychology was itself in its infancy, Eakins, like his contemporaries in the field of science, posed a set of questions aimed at determining the relationship of a child's intellect and actions. He had addressed a similar content in *Home Scene* (see page 43), a genre subject that is a portrait of his sisters Margaret and Caroline, and the theme recurs throughout his art (regardless

Thomas Waterman Wood
Susie Kent Southwick, 1873
The small scale and delicate colors of this delightful portrait, by Wood (American, 1823–1903), of two-year-old Susie Southwick are typical of what may be called the "souvenir" image—a relatively inexpensive work, the simplicity of which implies that the quickly changing features of the child do not warrant a more ambitious artistic effort. The controlled, almost static, pose of the toddler may indicate that the portrait was painted from a photograph.

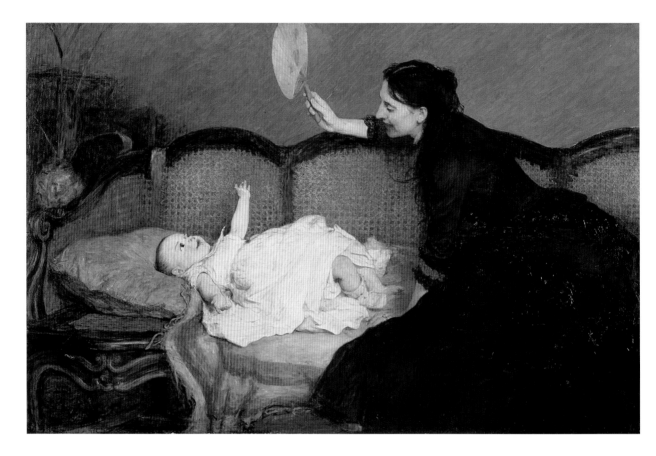

WILLIAM QUILLER ORCHARDSON
Master Baby, 1886
The title of this portrait of the artist's wife and their son Gordon affectionately refers to the infant's power to command center stage in family life. Just as his mother is shown devoting herself to amusing baby Gordon, so did Orchardson (Scottish, 1832–1910) depart from his customary subject-matter to devote his professional energies to depicting the family's pride and joy.

of the age of his sitter), often interpreted as evidence of his concern with the mysterious process of creativity.

Certainly the new attention to the complexities of children's minds and their view of the world contributed to the changing iconography of childhood in art. This is evident especially among the portrait painters, who, regardless of their stylistic affiliations, may be roughly classified as realists inasmuch as they dealt with obtaining a reasonable likeness of a sitter. Sargent, in particular,

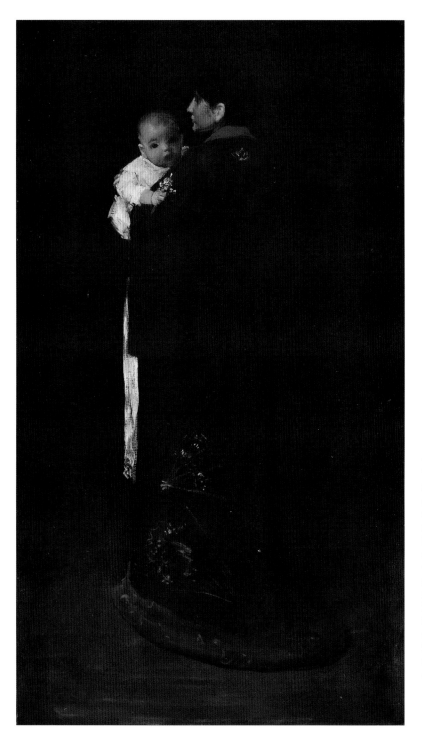

WILLIAM MERRITT CHASE
The First Portrait, c. 1887
Dark, black-on-black tonalities
splashed with passages of red and
white impart an uncommon severity
to this portrait of Chase's wife and
infant daughter. Critics recognized the
merging of Old Master characteristics
with a technique linked with modern
artmaking (especially Chase's
reputation as a proponent of the
Munich school of realism). A
beloved document of his family life,
the painting represented Chase at
important exhibitions throughout
the length of his career, where it was
admired for its dignity and restraint.

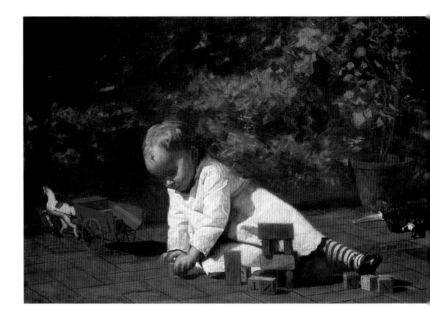

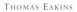
produced fascinating portraits that seem to attempt to penetrate the division separating adult and child interiority. Little Dorothy Williamson (see page 44) adopts a hieratic pose and authoritative solemnity more commonly associated with Renaissance portraits of popes or cardinals. While Dorothy confronts her viewers with a commanding look, another of Sargent's child subjects, Helen Sears (see page 45), appears lost in her own thoughts, oblivious to her surroundings. With a highly original compositional design Cecilia Beaux provides an encounter with her two-year-old niece Ernesta Drinker, who is seen from an angle that compels us to consider the world from her point of view (see page 46). In his portrait of John Alfred Parsons Millet (see page 47), Sargent turns the tables and portrays the boy from a low vantage point, thus permitting the

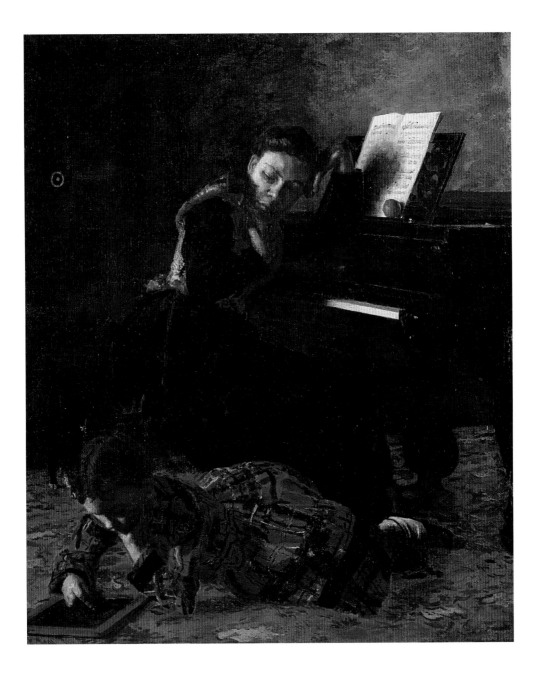

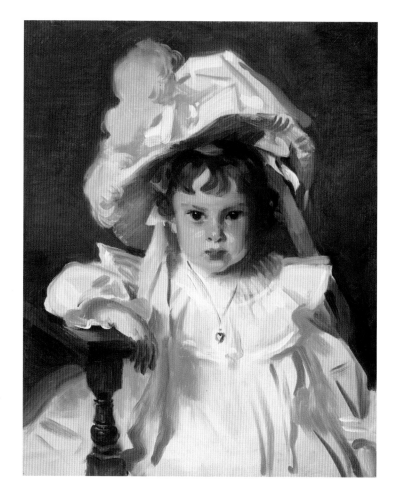

JOHN SINGER SARGENT
Dorothy, 1900
Sargent's depiction of Dorothy Williamson stands apart from many contemporaneous child portraits, for she is portrayed without sentimentality or an elaborate setting and typically "child-defining" accessories such as toys or pets.

(Opposite)
JOHN SINGER SARGENT
Helen Sears, 1895
In this portrait of the daughter of the Boston artist Sarah Choate Sears, Sargent revised the Romantic ideal that linked childhood with nature. Like the hydrangeas that surround her, the thoughtful little Helen is enclosed in a rarefied domestic environment, distanced from the sunlight that shines through the windows, reflected in the brass planter at her feet.

child to preside regally over his audience. All of these paintings encourage responses based on an understanding of each child as an individual, rather than simply as children in a generic sense.

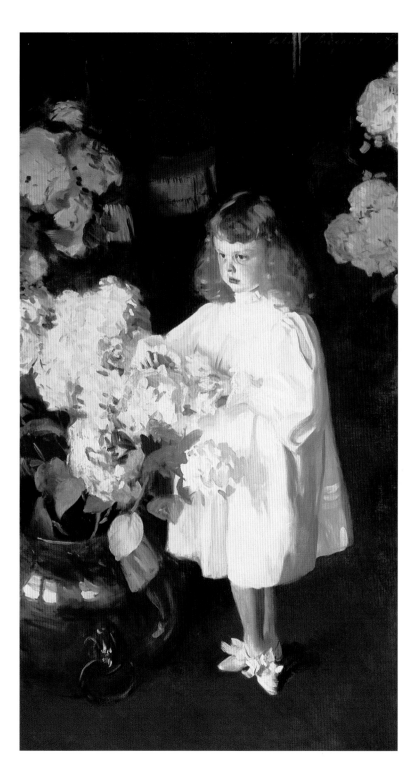

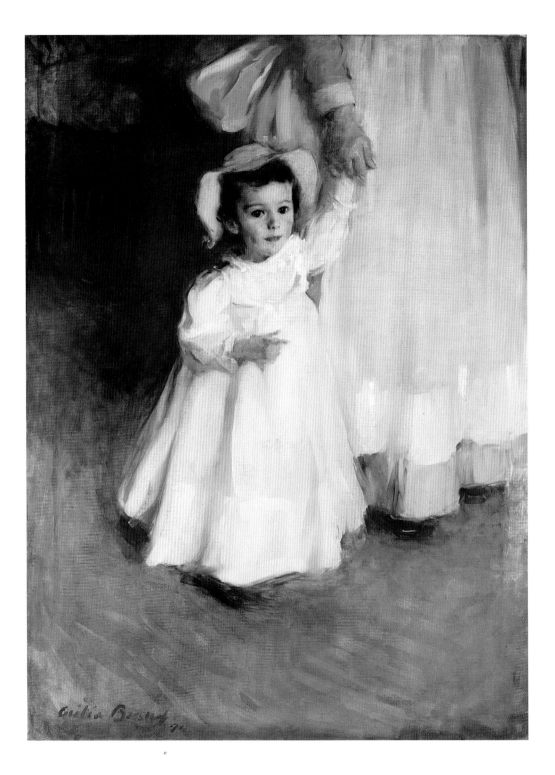

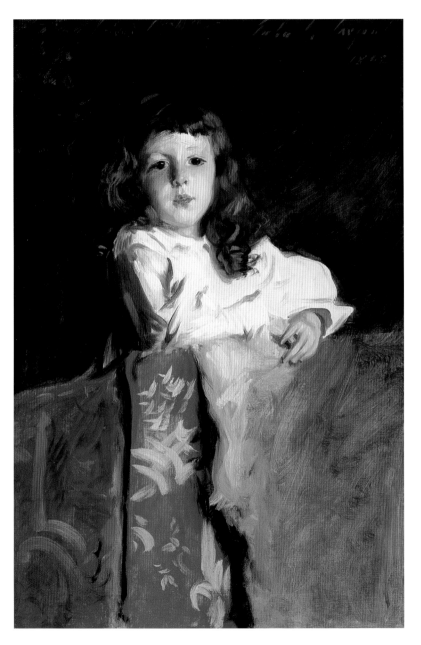

(Opposite)

CECILIA BEAUX
Ernesta with Nurse, 1894
Beaux's portrait of her niece impressed the critics as soon as it was exhibited in 1894 at the Society of American Artists. One writer declared the painting "brilliant and dashing"— uncommon terms for describing a portrait of a toddler but understandable here because of the sweeping lines, clear sense of movement, and directness with which the artist has portrayed the child as she takes her tentative steps toward independence under the guidance of her nurse.

JOHN SINGER SARGENT
John Alfred Parsons Millet, 1892
Sargent's portrait of his namesake and godson (the youngest child of the American artist Frank Millet and his wife, Lily) is a strikingly personal view of a favored child. The little boy's expression conveys a sense of his confidence and self-awareness in the situation of posing, while the loose, fluid brushwork implies Sargent's need to execute the portrait quickly, before young John's attention was diverted elsewhere.

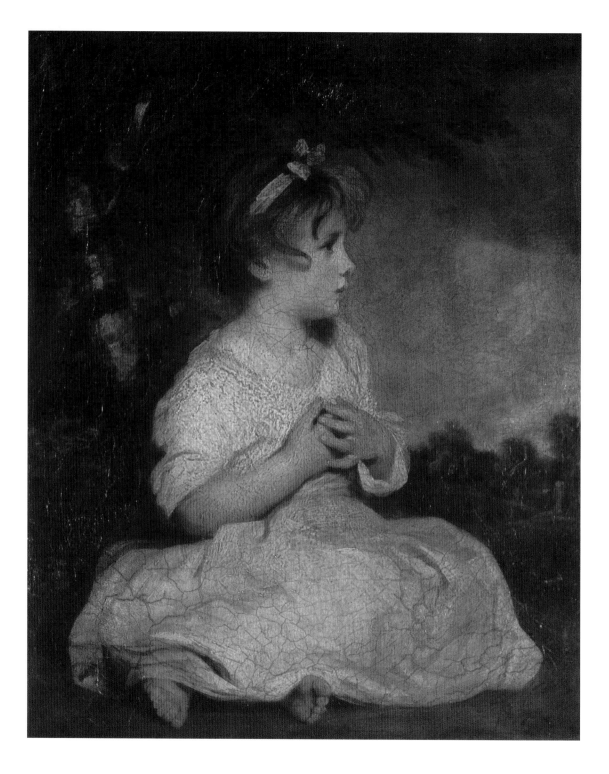

Nature's Child

Childhood had assumed a position of philosophical importance in the late eighteenth century owing, in large part, to the writings of Jean-Jacques Rousseau and John Locke. Both men incorporated childhood into theoretical discussions concerning the nature of mankind, concluding that children had particular needs that deserved accommodation in order for them to grow into worthy adults. Although Rousseau and Locke differed in their recommendations regarding children's training, their ideas were influential in introducing into art and literature the Romantic iconography of childhood innocence. The verses of the English poet William Wordsworth, exemplified by the oft-quoted lines "Heaven lies about us in our infancy" and "The Child is father of the Man," clearly allude to the beliefs spurred by these Enlightenment

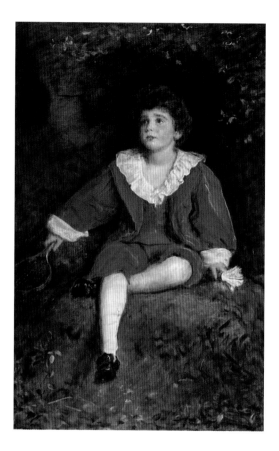

JOHN EVERETT MILLAIS
The Honourable John Neville Manners,
1896
In this portrait by Millais (English,
1829–1896), John Manners, the son
of Violet and Henry Manners (later
the Duke and Duchess of Rutland),
directs his attention heavenward, as if
seeking a sign of his future. His older
brother had died in 1894, leaving the
young John heir to the dukedom and
the responsibilities it entailed. (Both
boys are depicted on page 79.)

philosophers. So, too, does Joshua Reynolds's *The Age of Innocence* (see page 48), a painting of a little girl seated in the embrace of nature that soon came to stand as the quintessential image of the Romantic child.

The link between childhood and nature was founded on the biblical ideal of innocence, according to which a child could signify humanity's blameless existence as it was before Adam and Eve ate the forbidden fruit and were expelled from the Garden of Eden.

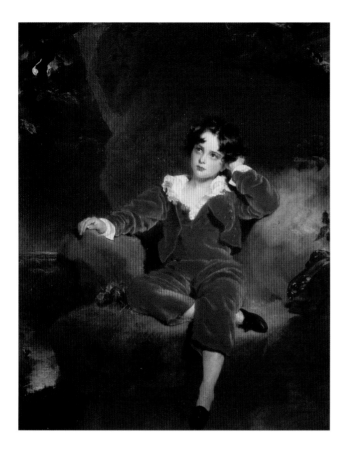

This meaning lingered, embedding within the imagery of childhood a sense of nostalgia—not only for humanity's lost, uncorrupted state of grace but also for the unreachable feelings of innocent wonder that individuals could only vaguely recall from their own early years. John Everett Millais, one of Victorian England's most successful painters of children, unabashedly recalled this nostalgic content in *The Honourable John Neville Manners* (opposite), a portrait that clearly draws on Thomas Lawrence's *Charles William*

THOMAS LAWRENCE
Charles William Lambton,
exh. RA, 1825
This work by Lawrence (British, 1769–1830) and others of its type enjoyed renewed popularity during the late nineteenth century. Millais, who was probably already familiar with this painting, would have had the opportunity to see it at the Grafton Gallery's Exhibition of Fair Children in 1895, the year before he received the commission to paint John Manners's portrait (opposite).

51

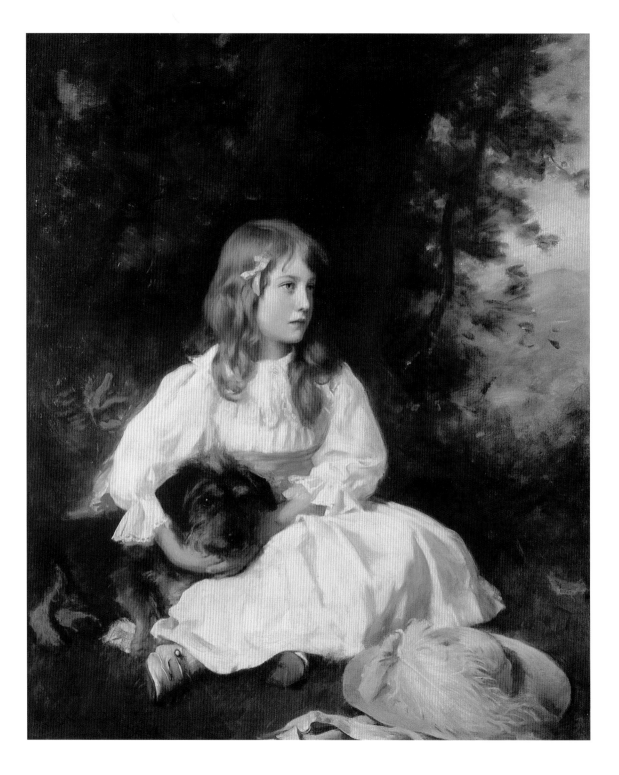

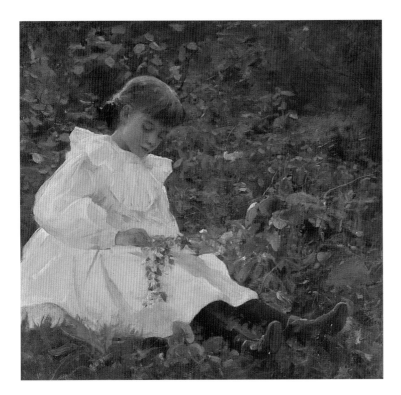

Lambton (see page 51), painted earlier in the century. Indeed, there is little to separate the two pensive boys iconographically except for John Manners's shuttlecock and battledore, trappings of the then popular game that help pinpoint his portrait's late nineteenth-century origins. Millais, however, was not simply reiterating Enlightenment ideas through this type of appropriation; by referring to a known and respected painting by Lawrence, he confirmed the strength and continuation of a national art and, at the same time, asserted a similar claim for one of England's noble families.

(Opposite)
WILLIAM ROBERT SYMONDS
Heather, 1904
The portrait by Symonds (British, 1851–1934) of the white-gowned Heather seated on a grassy spot in a wooded landscape is clearly an updated version of Reynolds's little sitter in *The Age of Innocence* (see page 48). Symonds's inclusion of the dog additionally refers to the concept that children, like animals, function on an intuitive, elemental level.

DOUGLAS VOLK
Little Marion, c. 1899
This close-up, horizonless view by Volk (American, 1856–1935) of a little girl seated in the open air captures the essence of childhood's remoteness from adult cares and implies that the limited sphere of the child's world nonetheless seizes her every attention.

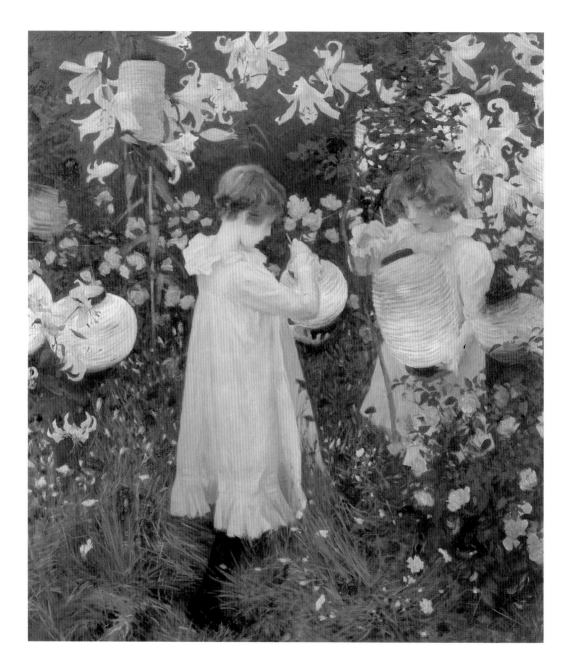

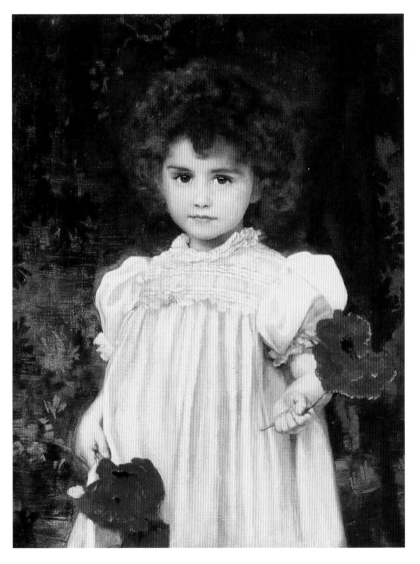

JOHN SINGER SARGENT
Carnation, Lily, Lily, Rose, 1885–86
Although in most respects this painting
functions in terms of genre, the image
of the two girls also registered as a
portrait for the members of the
Broadway artists' colony, who knew
the children and watched them pose
in the open air of mild evenings. As
the American painter Edwin Blashfield
recalled, "We would all leave our tennis
for a time and watched the proceeding.
Little Pollie and Dollie Barnard . . .
would begin to light the Japanese
lanterns among the tall-stemmed lilies."

WILLIAM CLARKE WONTNER
Edith Francis Moir (Connie), 1898
The solemn little girl painted by
Wontner (British, d.1930) is a picture
of innocence. Yet *Connie* delivers a
bittersweet message in the poppy that
she tenderly offers; as a symbol of sleep
and death, the flower embodies the
nostalgic meaning of childhood's short
duration and the brevity of life itself.

The Romantic vision of childhood persists today (with some "age-appropriate" revisions), but it enjoyed particular currency during the Gilded Age. Vestiges of Reynolds's innocent little girl emerge in a variety of works (see pages 52–55), the most famous of which is probably Sargent's *Carnation, Lily, Lily, Rose.* Although technically not a portrait, the painting certainly functioned as such for the small group of artists, writers, and their families clustered in the village of Broadway in Gloucestershire, England, where Sargent periodically worked on it in 1885 and 1886. The models, Polly and Dolly, were the daughters of the painter–illustrator Frederick Barnard, whose family was frequently in residence in the idyllic art colony. The painting was first shown in 1887 at the Royal Academy, where it shocked critics—not because of its subject-matter but because of its radical Impressionist style. Those who were not put off by Sargent's technique (an unwelcome reminder of French influence) fell under the spell of the two little girls lighting lanterns in a twilit English garden. Sargent had already experimented in expressing the time-honored English theme of childhood in an avant-garde visual language (opposite), subjecting his little models to even greater formal extremes.

The motif of the child in a landscape setting took on additional meaning as the definition of childhood shifted, placing new emphasis on adolescence. In this context the physical and emotional changes associated with this phase of maturation were sometimes correlated with the inevitable cycles and changeable aspects of nature (see pages 58–59).

JOHN SINGER SARGENT
Garden Study of the Vickers Children,
1884
Billy and Dorothy Vickers, the children of two of Sargent's important English patrons, share the duties of watering one of the lilies that surround them. Here the artist mixed traditional imagery with avant-garde technique: the garden setting and the lily (often a symbol of purity) establish a metaphor for interpreting the children's innocence, and the unusual perspective, absent horizon line, and broad, sketchy brushstrokes aligned Sargent with modern French painting styles.

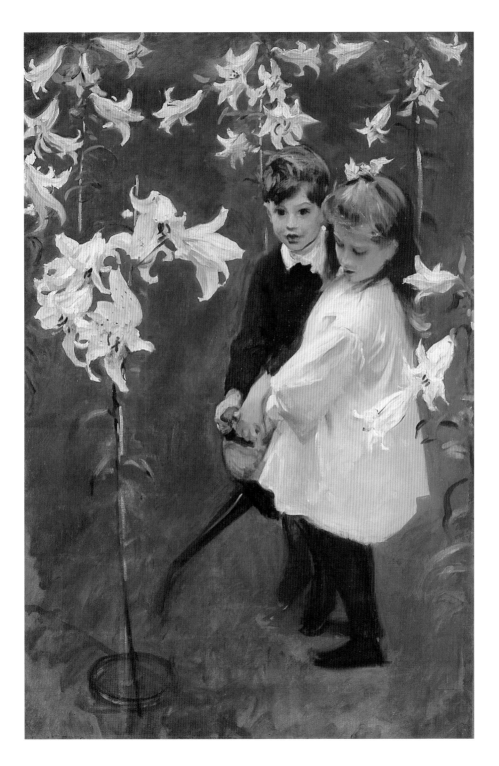

CECILIA BEAUX
Dorothea in the Woods, 1897
Dorothea was the eldest daughter of
the New Yorkers Helena de Kay Gilder
(a painter) and Richard Watson Gilder
(a poet and the editor of *The Century
Magazine*). Beaux's friendship with the
couple doubtless gave her the latitude
for this bold and unconventional
portrait of the fifteen-year-old girl,
who is portrayed as having the
withdrawn, almost sullen, persona
often associated with the natural
mystery of adolescent behavior.

(Opposite)
DOUGLAS VOLK
Boy with an Arrow, 1903
A romantic landscape forms the
backdrop for a contemplative moment
taken by the artist's son Leo. Such
imagery, so redolent of youth's dreams
of the future, corresponded to
contemporary notions of adolescence
as an important transitional stage
of development requiring periods of
introspective repose to counterbalance
the tumultuous physical changes that
occur during puberty.

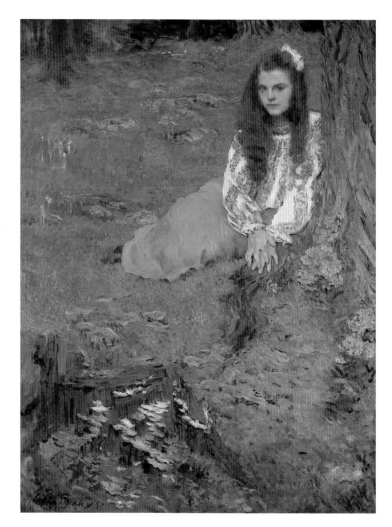

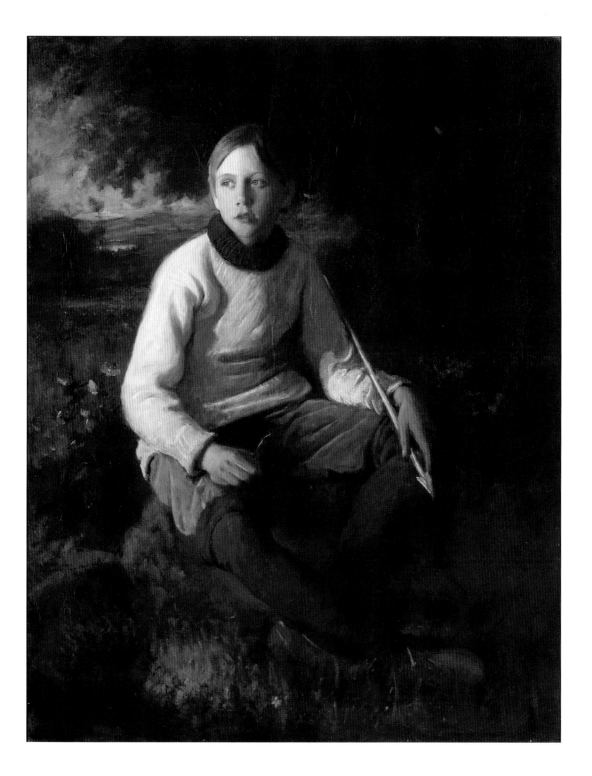

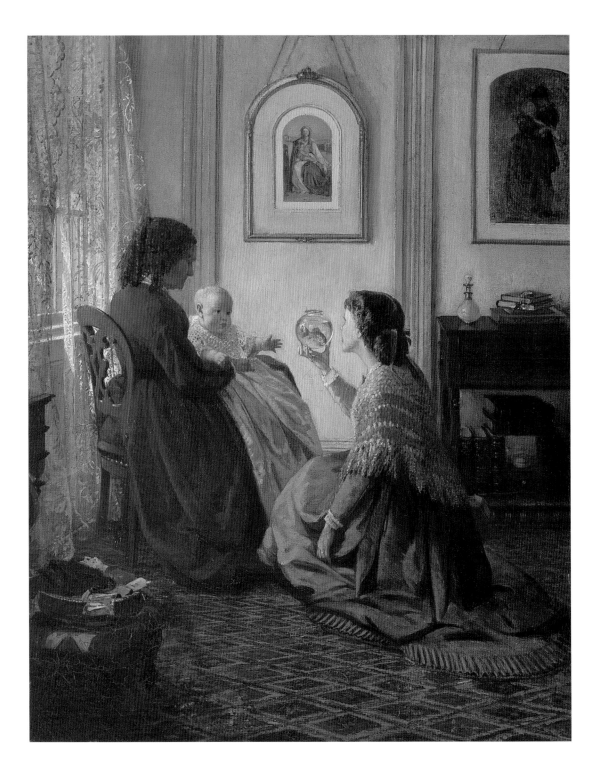

The Sacred Child

AARON DRAPER SHATTUCK
*The Shattuck Family, with
Grandmother, Mother, and Baby
William*, 1865
This highly detailed painting by
Shattuck (American, 1832–1928),
executed in a manner reminiscent of
Pre-Raphaelitism, is the artist's private
tribute to the sanctity of family life.
The familiar device of including a
painting within the painting leads the
viewer to associate the three Shattuck
generations with the traditional motif
of the Virgin and Child with St. Anne,
a connection confirmed by the artist's
placement of the engraving after Paul
Delaroche's *Madonna and Child*
directly above them.

Notwithstanding the growing tendency to appreciate children as
individuals, the inclination to interpret any mother-and-child image
within the iconographic template of the Christian Virgin and Child
was inescapable. Artists had, of course, relied on associations
with the venerable motif for years (opposite). And, although some
Gilded Age artists persisted in making overt references to the Virgin
and Child, both visually and through the titles of their works (see
pages 62–63), most skirted doctrinal issues by omitting religious
symbols and by emphasizing the contemporaneity (and actuality) of
their sitters. Abbott Handerson Thayer especially called on such
intangible associations in portraits of his family, intentionally
imbuing them with a spiritual meaning that drew from Christian
imagery, without engaging religious theory (see pages 64–65). This

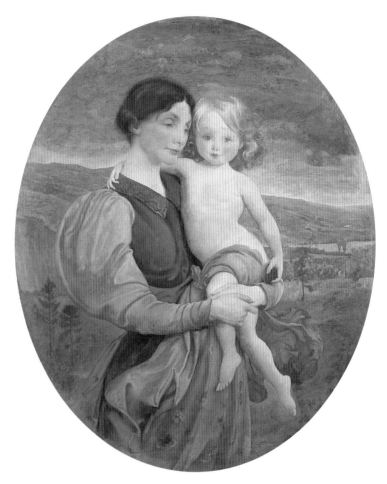

pictorial trend reflected broader cultural attitudes. For American artists struggling to assert a presence in the international art world, the deliberate adoption of such motifs aligned their work with that of the great masters of the European tradition. Moreover, such imagery held a dual function: on the one hand, it helped to justify the materialism of the era while, on the other, it also presented an

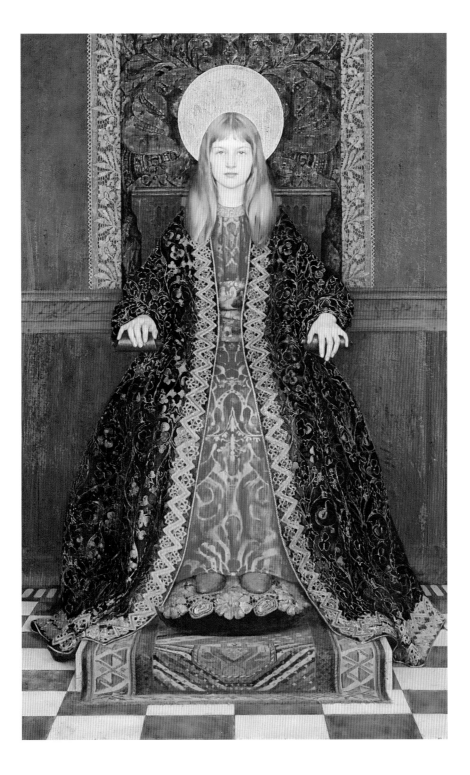

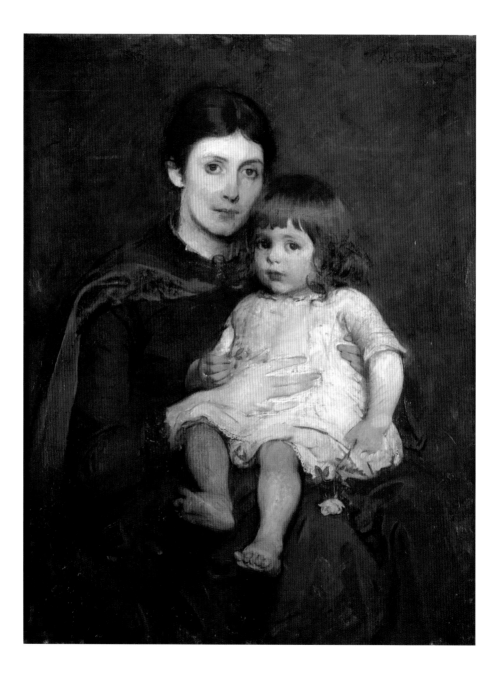

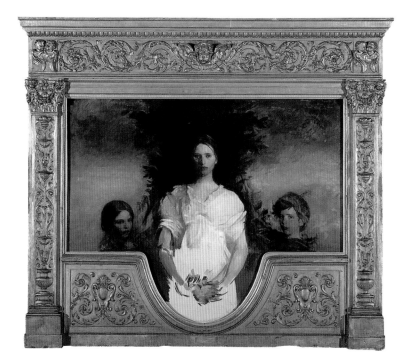

argument against it. These conflicting purposes were resolved within the image of the child, for by positioning the child as sacred, adults could reconcile their quests for financial gain with the notion that all was done for the sake of the family. And, as some writers of the period argued, if financial success was central to preserving the family, then it was also central to preserving the values of Western civilization. The status of the nineteenth-century child as a metaphor for hope and cultural redemption declared a generation's faith in the future, physically represented in its offspring.

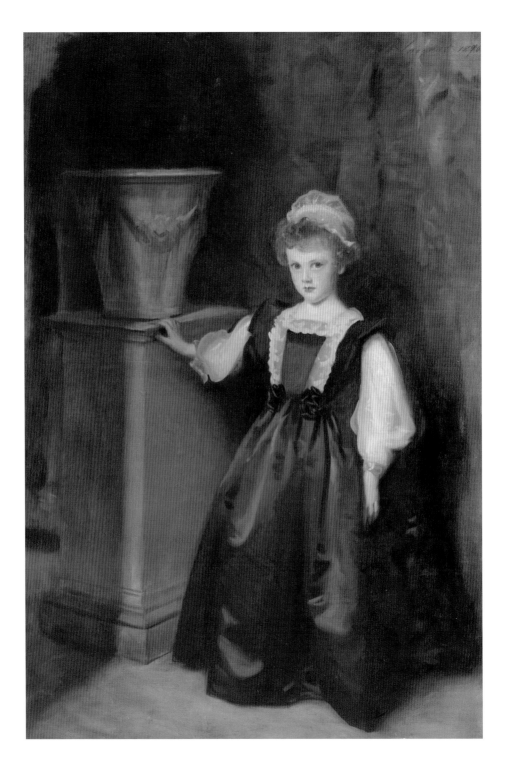

The Grand Manner Child

The mother-and-child theme presented in the Grand Manner portrait mode was a winning combination in the eyes of most Gilded Age critics. Such works as Sargent's *Mrs. Edward L. Davis and her Son Livingston Davis* (see page 68) immediately drew favor in public exhibitions not only because of the appeal of the imagery but also because they embodied the living evidence of an ideal in formal terms that recalled the great portrait masters of the past— most notably Anthony van Dyck, Joshua Reynolds, Thomas Gainsborough, and Thomas Lawrence (see page 69). The Grand Manner style was revived in the last decades of the nineteenth century, reemerging after a period of dormancy that had begun with Lawrence's death in 1830. The conditions contributing to the resurgence were based largely on economic and social shifts within

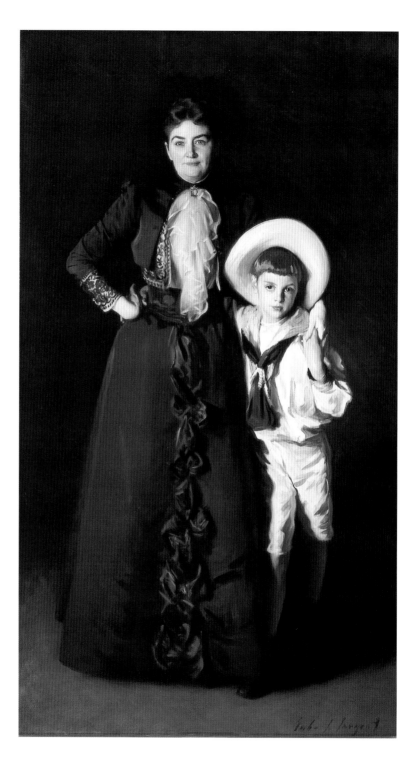

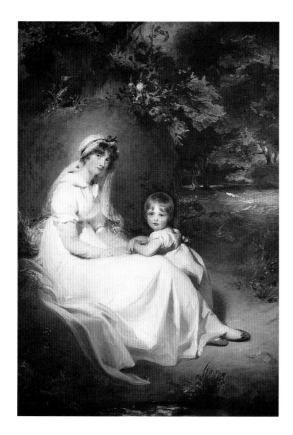

England that affected the taste and desires of moneyed classes that now included not only the aristocracy but also the rising meritocracy—the possessors of new fortunes founded on the industrial and commercial expansion that marked the Victorian age. For the holders of new wealth the commissioned portrait provided personalized evidence of financial success and enabled them to enhance that status with a polished veneer of social acceptability acquired through the role as art patron. For others the acquisition of this type of portrait represented a continuation

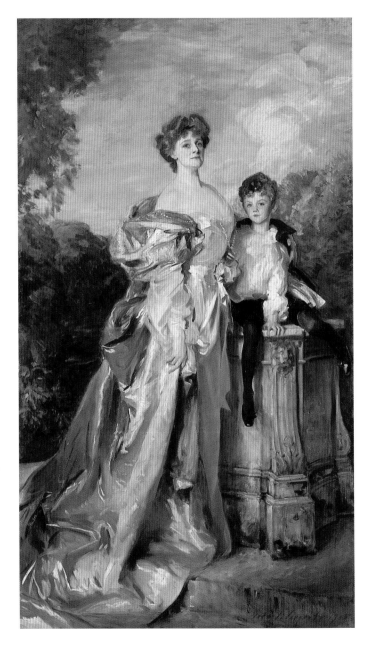

JOHN SINGER SARGENT
The Countess of Warwick and her Son,
1905
Despite the formality of this portrait,
Sargent clearly shows the power held
by Maynard over his mother, the
statuesque beauty Frances Evelyn,
Countess of Warwick. The boy grasps
his mother's pearls, as if to show his
ownership of her affections, and he is
lovingly supported by her (aptly
enough on a pedestal) to suggest her
willing and proud surrender to the
demands of motherhood.

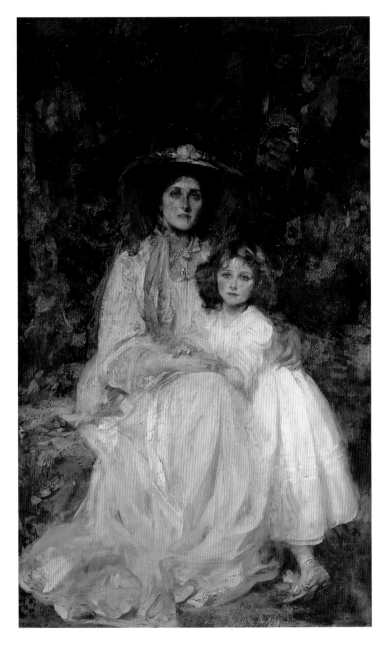

JAMES JEBUSA SHANNON
*Lady Dickson-Poynder and her
Daughter Joan, c.* 1905
Shannon, like Sargent, participated
in the revival of older portrait formats.
This romantic image of Lady Dickson-
Poynder protectively embracing her
daughter in a forested setting relies
intentionally on Lawrence's portrait
of Lady Templetown and her son
(see page 69) and was meant to convey
the natural intimacy between mother
and child.

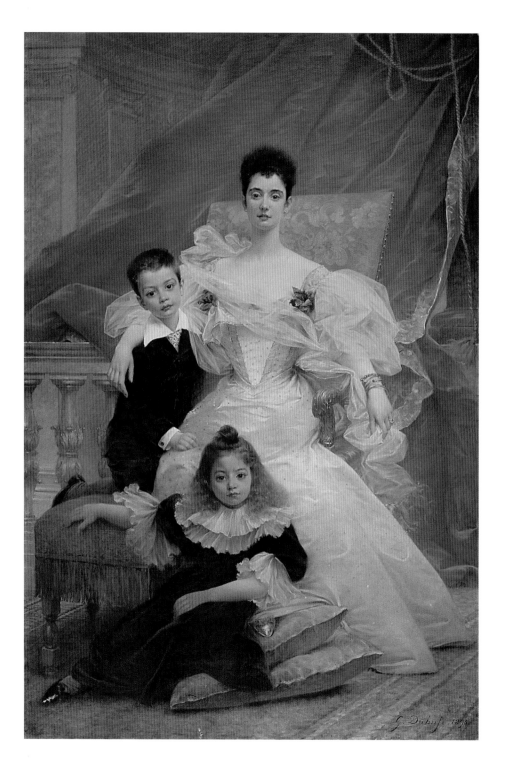

of family tradition, inasmuch as aristocratic families often commissioned works that would harmonize in size and compositional format with the portraits of their ancestors that already occupied the walls of their palatial homes (see page 66).

As reincarnated in the late nineteenth century, the Grand Manner mode was remarkably flexible stylistically; although linked by the defining elements of large scale and the privileged status of the persons portrayed, the portraits that fall within this category reveal a wide array of differences attributable to national tastes as well as to the personal preferences of artist and client. Such considerations—cultural and individual—account for the more *retardataire* approach exhibited in English portrait commissions. Sargent's *The Countess of Warwick and her Son* (see page 70) and J.J. Shannon's *Lady Dickson-Poynder and Her Daughter Joan* (see page 71) rely heavily on the Reynolds–Gainsborough–Lawrence lineage, deliberate artistic choices that underscore the realities of the social and artistic hierarchies particular to England. Indeed, they confirmed the stability of the English class system by picturing the most recent generational chapters in the dynastic heritage of two notable families.

While the message of continuing family traditions and bloodlines was implicit in these images, the visual language for expressing such content within the Grand Manner format varied from nation to nation. In France, for instance, audiences were likely to associate Guillaume Dubufe's massive portrait of *Madame de Beauchamp and her Children* (opposite) with the traditional iconography of

GUILLAUME DUBUFE
Madame de Beauchamp and her Children, 1895
Despite the grandiose theatricality with which this mother and her children are presented, Dubufe's arrangement of the three figures subtly recalls a standard image of Charity—a mother offering her breast to one child with another at her feet. This striking blend of visual extravagance and maternal benevolence was deliberate, for Dubufe (French, 1853–1909), wanted to create an image of a modern, worldly woman, whose values remained grounded in the highest virtues.

73

Charity, as personified by a mother and two children. The motif had a strong history in France, where it resonated with political ideals perpetuated by the state and gained particular prominence during the nineteenth century. Dubufe's imagery, however, is tenuously balanced between the moral rectitude of Charity (a subject ordinarily treated with solemnity and austerity) and the Baroque splendor of the scene. Yet the potential conflict between the two elements (moral restraint and visual excess) is resolved by the dominant triangular shape formed by the mother and children, which endows the composition with a sense of permanence. In the United States, Sargent's forthright portrayal of the affectionate relationship between Mrs. Davis and her son prompted reviewers to see in it the wholesome promise of the nation's youth who would lead the country to even greater heights (see page 68). Thus, whether they were conservative, flamboyant, or somewhere in the aesthetic middle ground (opposite), Grand Manner society portraits of children and their mothers reinforced the belief that children were the deserving receptacles of the emotional and economic energies of the Gilded Age.

FRANK WESTON BENSON
Mrs. Benjamin Thaw and her Son Alexander Blair Thaw II, 1900
A mixture of formality and tranquility characterizes this portrait of Emma Dows Thaw (the wife of a wealthy Pittsburgh industrialist) and the youngest of her five children. Benson (American, 1862–1951), poses the elegantly dressed pair against a backdrop of lush foliage that gives way to a distant view of a coastline at sunset. In turn, the sturdy, columnar form of the mother shields the toddler, as if to protect him from the world beyond the domestic sphere.

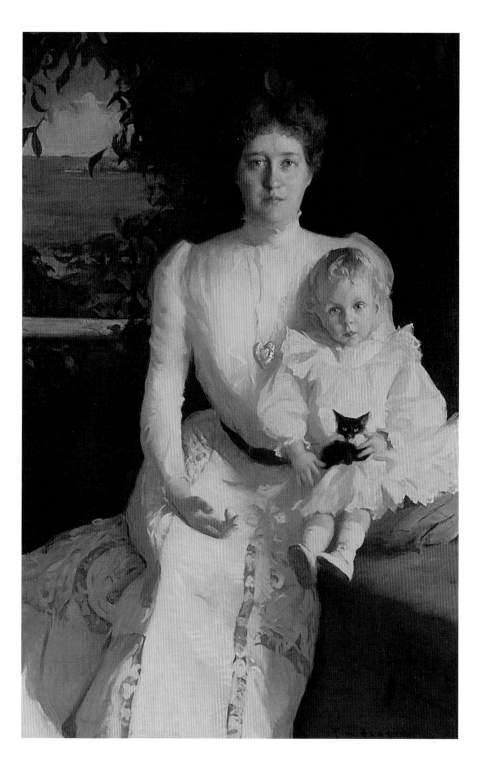

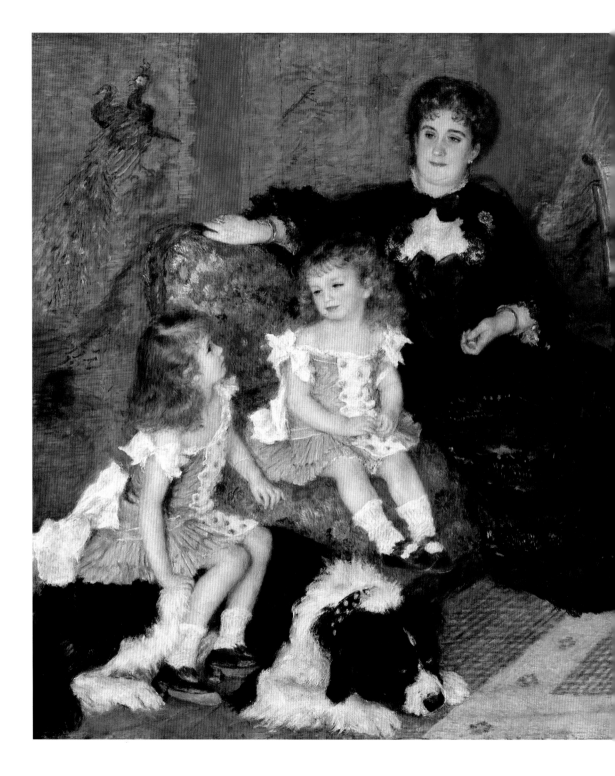

Looking the Part

Late nineteenth-century clothing and hairstyles for very young children were not gender-specific. Consequently it is often extremely difficult to distinguish boys from girls in portraits when the children in question are under five or six years of age—the point when boys were usually "breeched" (a term meaning that they began wearing breeches, or pants, instead of dresses) and their long curls of babyhood were shorn (see page 78). This custom is clearly

(see page 78)

PIERRE-AUGUSTE RENOIR
Madame Charpentier and her Children, 1878
Displayed at the 1879 Paris Salon, this large canvas provided an intimate view of the otherwise very public life of Madame Georges Charpentier, the wife of the famed publisher and promoter of the Impressionists, who was a noted figure in her own right in literary and artistic circles. Madame Charpentier is shown as a benevolent, loving mother, seated in the privacy of her boudoir with her two children, Paul and Georgette, both of whom are dressed alike according to fashionable bourgeois taste.

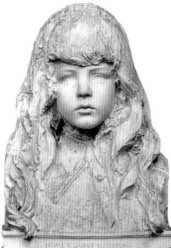

Augustus Saint-Gaudens
Homer Saint-Gaudens, 1885
Homer Saint-Gaudens often modeled
for his father and was also the subject
of John Singer Sargent's highly
acclaimed *Portrait of a Boy* (see page
94). He would have been about five
or six when his father sculpted this
portrait bust, perhaps as a souvenir
of a phase of life that would soon come
to a close, signified by the cutting of
the long flowing tresses of babyhood.

apparent in numerous works, including Renoir's glowing portrait of Madame Georges Charpentier and her children Paul and Georgette (see page 76)—it is Georgette who perches on the family dog Porthos—and J.J. Shannon's *Children of the Marquess of Granby* (opposite), which shows young Lady Marjorie Manners seated in the family's silver punch bowl-cum-chariot while her brothers Lord John Manners (the subject of Millais's portrait reproduced on page 50) and Lord Haddon cajole the family dog into playing horse.

As might be expected, most formal portraits show children in their best outfits and posed on their best behavior—requirements imposed by the artist and/or parents that frequently inflicted great discomfort on the sitters. The sisters Dorothy and Irene Falkiner, dressed in fur-trimmed coats and hats, surely suffered from the heat during their sittings in the artist's studio (see page 80) and a sign of such physical distress may be detected in the cheerless expression on the face of the younger girl. In contrast, Beaux's nephew Cecil Drinker seems to have borne his studio ordeal stoically, responding to his aunt with a good measure of stubborn pride (see page 81). In these examples and others (see page 82) the costumes—then the height of children's fashion—often overpower their wearers yet signify the family's status, ambitions, and beliefs about children.

Artists also followed a standard strategy of portraying children with attributes—toys, books, flowers, and pets—that would help "explain" the character of their sitters (see page 83). This method of picturing children had been in place for centuries and had grown

from a tendency to see youngsters as having unformed personalities that were more or less cut from the same cloth. The image of a child with a kitten or a puppy, for example, was intended to inject the notion of the child's helplessness or the need for training before entering the "civilized" arena of adult society. Flowers, ordinarily emblematic of the transitory nature of beauty, were constant reminders of the swift passage of time (and consequently the brevity of childhood) or the fragility of the precious child (in the light of child mortality rates and the late nineteenth-century trend for smaller families). Toys, of course, implied that the business of child-hood was play and also perpetuated the mistaken notion (or rather,

JAMES JEBUSA SHANNON
The Children of the Marquess of Granby, c. 1893
Echoes of Anthony van Dyck's famous painting *The Five Children of Charles I* (Royal Collection) are evident in this portrait of three of the Manners children, whose parents later became the Duke and Duchess of Rutland.

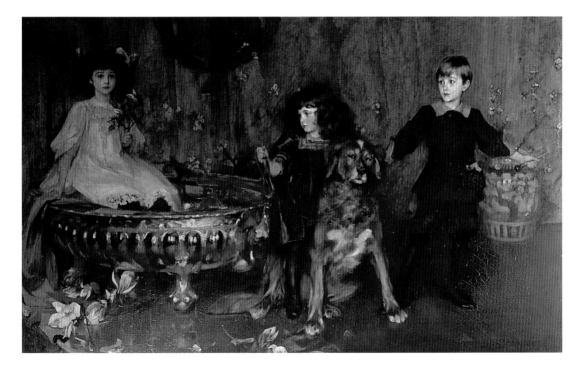

79

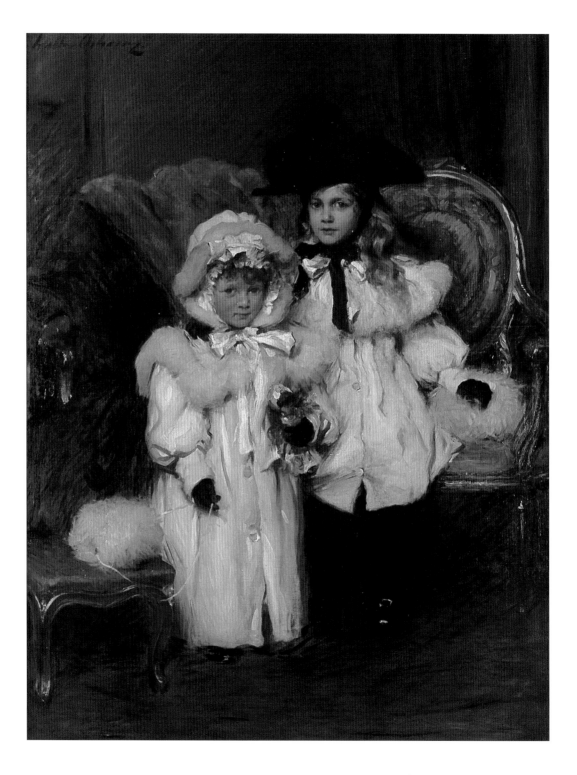

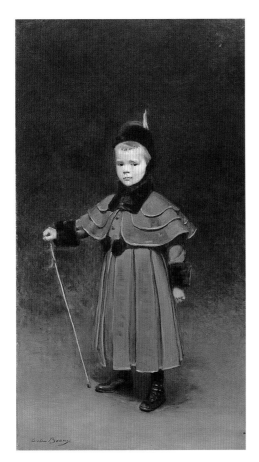

WALTER FREDERICK OSBORNE
Dorothy and Irene Falkiner, 1900
This portrait by Osborne (Irish, 1859–1903), of two little girls decked out in their finery, represented him at the Paris Exposition of 1900, where it presented a pure and positive vision of contemporary childhood. This attitude stood in contrast to that contained in a host of works whose imagery forecast a less optimistic future for humanity because the moral depravity of adults was believed to be manifested in the young.

CECILIA BEAUX
Cecil Kent Drinker, 1891
The dark palette of browns and blacks and the absence of furnishings lend a severity to this full-length portrait of the artist's nephew. The sturdy little boy adopts a pose based on Velázquez's famous portrait of the six-year-old Spanish prince Baltasar Carlos as a hunter, thus adding to the impression that Cecil is himself a little prince in his own domestic milieu.

hopeful belief) that little else entered the child's mind. Books held a dual function since they referred not only to schooling but also to the fairy world of the child's imagination—a reflection of the lucrative publishing industry devoted to children's literature that arose in the late nineteenth century (see page 84).

The use of such child-defining imagery cut across national and stylistic boundaries. Early in his career Sargent followed the

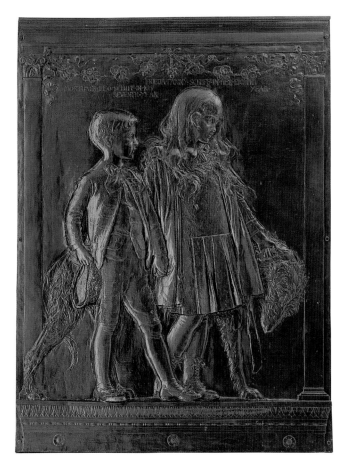

example of his French master Carolus-Duran by adopting his teacher's academic formula for portraying children in formal portraits (see pages 85–86). The American painter Frank Duveneck applied his dark, Munich-inspired realist style to five-year-old Bostonian Mary Cabot Wheelwright, at whose feet lie discarded flowers (see page 87). The pink blooms, along with the doll she clutches rather mechanically to her side, act as conceptual footnotes

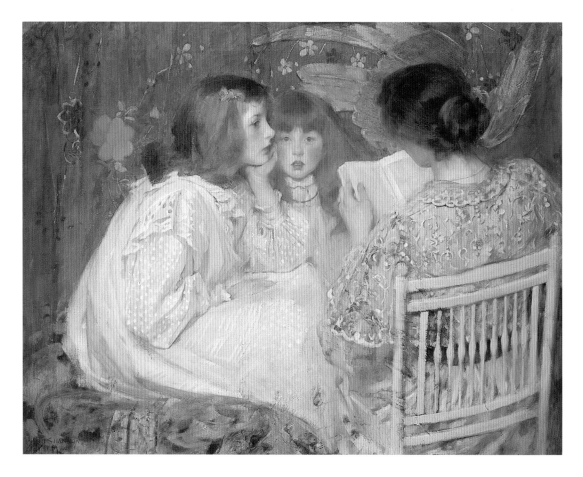

JAMES JEBUSA SHANNON
Jungle Tales (also known as *Fairy Tales*), 1895
Shannon chose a highly decorative genre format to depict his daughter Kitty (left), Nora, the daughter of artist Edwin Ward (center), and his wife, Florence. The familiar scenario of an adult reading to children allows the artist to concentrate on the varied emotional responses of the child listeners—elements outside the range of expression ordinarily called for in commissioned portraits.

referring to her projected destiny as wife and mother. Renoir's *Children's Afternoon at Wargemont* (see page 88), a triple portrait of the daughters of the French diplomat–banker Paul Berard, presents an idealized picture of the protected, enclosed world of childhood and, through the attributes of doll, book, and the eldest girl's sewing activity, outlines the pursuits appropriate to each child's age. In England audiences viewed Shannon's painting of Offie Laidlay comfortably ensconced on the floor with her book and pet terrier (see page 89).

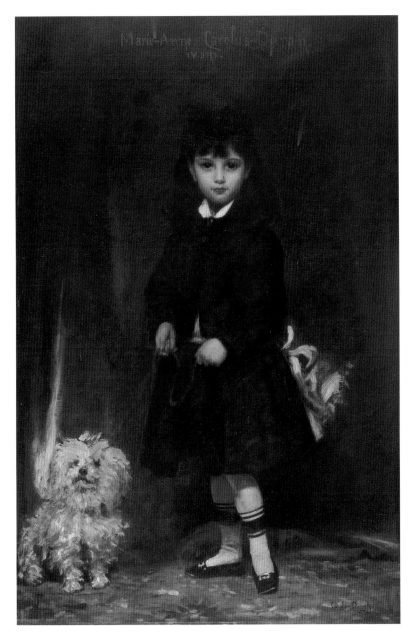

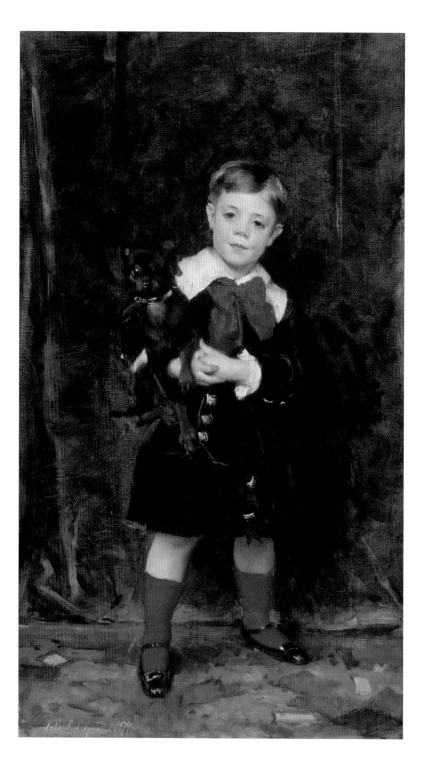

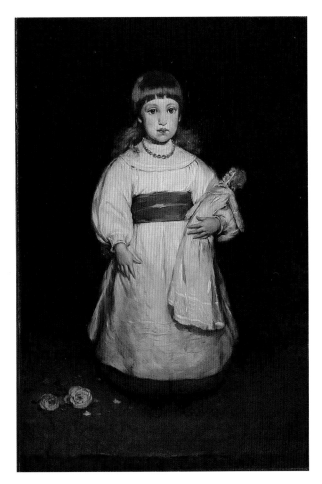

(Opposite)

JOHN SINGER SARGENT
Robert de Cévrieux, 1879
At first glance Sargent's portrait of little Robert seems simply to echo the formula of child portraits that he learned in the studio of his teacher Carolus-Duran (see page 85). However, this lively portrayal of a youngster struggling to manage his squirming pet encourages us to empathize with his efforts to control the terrier and maintain his pose.

FRANK DUVENECK
Mary Cabot Wheelwright, 1882
Although noted for an energetic painterly style associated with his Munich training, Duveneck (American, 1848–1919), discarded that mode in favor of a more restrained technique that doubtless conformed to the expectations of the wealthy Boston couple who commissioned this formal portrait of their four-year-old daughter. Although Mary is prim and proper, and possessed of the external attributes of childhood (the doll and the flowers), Duveneck successfully brings to life a sense of her confusion from having to pose.

Offie Laidlay's open smile signals her guileless receptivity and seems to corroborate the old and firmly held presumption that children's thoughts were completely accessible and uncomplicated. However, other images of reading children contradict that impression (see page 90) and may be seen as general indications that the imagery of childhood was shifting in reaction to the growing

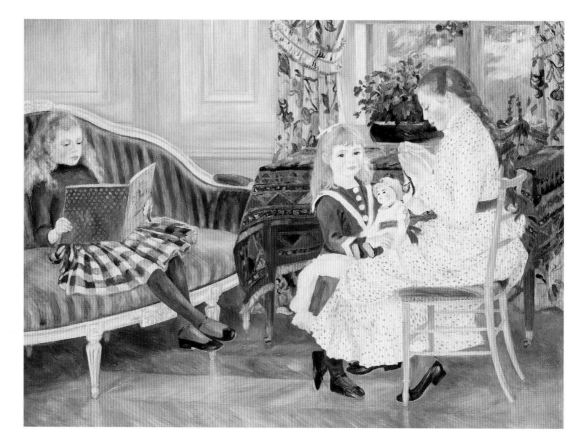

PIERRE-AUGUSTE RENOIR
Children's Afternoon at Wargemont,
1884
This ambitious canvas is one of the
fourteen family portraits Renoir
executed for his patron, the banker and
diplomat Paul Berard. Three of Berard's
daughters are cast as ideal children,
engaged in quiet, constructive activities
that may be read as preparations for
adulthood, creating an image that
contradicts another artist's opinion
of the girls as "unruly savages who
refused to learn to write or spell."

realization that children were individuals capable of independent thought and action. What children knew and how they learned were topics of intense scientific interest beginning in the 1880s. Thousands of children were interviewed in studies devised by G. Stanley Hall (a pioneer in developmental psychology) and the results tabulated and published. Although these studies were not widely read outside the field, the information gathered by Hall and others soon filtered into the public sphere, causing adults to see

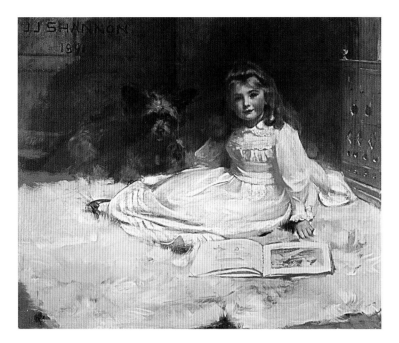

children differently. Of course, such investigations were not solely responsible for revisionist thinking, but they are symptomatic of the changes in how children were perceived that took place during the Gilded Age. Intimations of the child's transformation from idea to individual surface particularly in portraits by Sargent (see pages 91–92). Caspar Goodrich and Cara Burch are posed without accessories and confront us with guarded, examining expressions. The myth of the malleable child was also challenged, for example in Boldini's portrait of an unmanageable Piccolo Subercaseuse (see page 93) and Sargent's *Portrait of a Boy* (*Homer Saint-Gaudens and his Mother*) (see page 94). These paintings feature the restlessness of each boy, countering the stereotyped portrayals of

JAMES JEBUSA SHANNON
Offie, Daughter of A. Laidlay, Esq.,
1891
Shannon's charming portrait of the daughter of a painter colleague maintains the idealized Victorian conception of childhood as a life passage meant to be separate from the adult sphere. While still adhering to the formula of portraying children with attributes that symbolize their nature (the dog, the picture book, and the child's "lowly" situation on the floor), Shannon nonetheless endows Offie with an alert, responsive expression that suggests an awareness of things beyond her enclosed world.

89

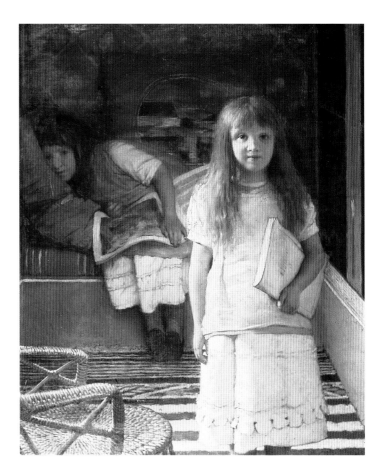

*This is our Corner (Portrait of
Laurense and Anna Alma-Tadema),*
1873
The title of this intimate painting
of the artist's daughters plays on the
growing perception of childhood as
a state of being remote from adult
understanding. One girl shrinks shyly
into the cushions, clutching her book
(a symbol of her interiority), while the
other stands solidly at the threshold of
the pictorial space, as if to remind the
viewer that it is impossible to re-enter
the territory of childhood.

childhood that still held sway. Yet Sargent's painting was an
immediate source of fascination for critics, one of whom observed
that, although Sargent did not idealize his sitter, "a look into the
boy's bright humid eye is worth more than pretty exaggerations and
polite restraints."

In a sense this comment, an acknowledgment of the artifice of
the era, was a portent of the passing of the Gilded Age. By the time

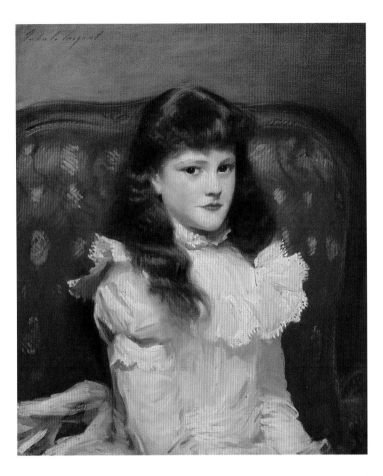

the privileged children whose portraits are reproduced here reached adulthood, the world had changed and the realities they ultimately faced were far from what their parents had pictured for the coming generation. Nonetheless, these works still exude an unbounded faith in the future that perhaps adds another layer of nostalgia for the present-day viewer.

JOHN SINGER SARGENT
Cara Burch, 1888
Ten-year-old Cara Burch (Sargent's distant cousin by marriage) sits stiffly erect and confronts her viewers with a riveting gaze. The dramatic contrast between her starched white dress and the red chair in which she sits augments the sense of her contained nervous energy, thus encouraging us to react to her as a distinct personality.

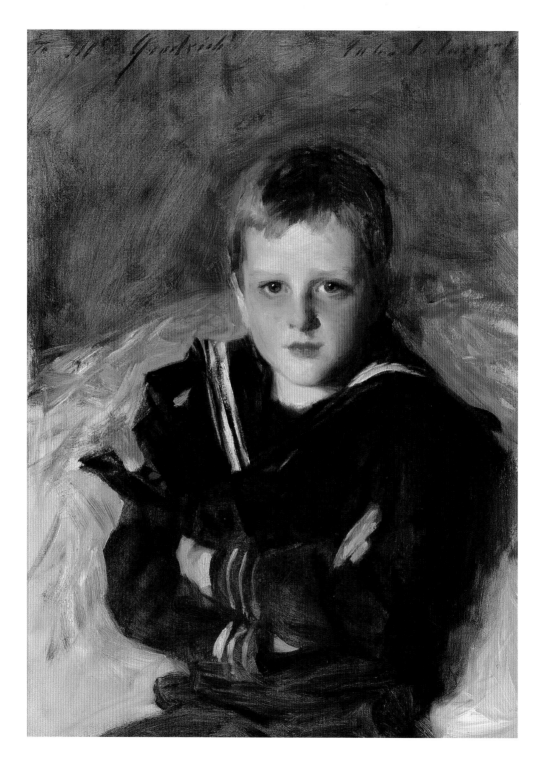

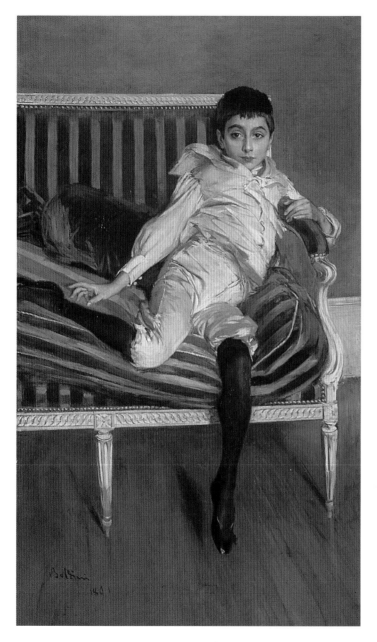

JOHN SINGER SARGENT
Caspar Goodrich, *c.* 1887
Caspar Goodrich's sailor suit was
more than a mere concession to
children's fashion; his father was
Rear-Admiral Caspar Goodrich, who
instilled in his son the high standards
of naval tradition. Sargent may have
intended especially to please the boy's
father by investing this portrait with
an almost unnerving authority, thus
paralleling his family's hopes for him.

GIOVANNI BOLDINI
*A Member of the Subercaseuse
Family (Piccolo Subercaseuse)*, 1891
Boldini executed several portraits for
the Subercaseuse (or Subercaseaux)
family, among which were his typically
dashing, fashionable society portraits
and the sober portrait of this boy's
brothers (see page 17). In contrast
to the latter, Boldini has created
a brilliantly mannered portrayal
of a distracted young Piccolo, whose
pose bridges the divide between the
deliberate affectations of his dazzling
depictions of adults and the unself-
conscious movements of children.

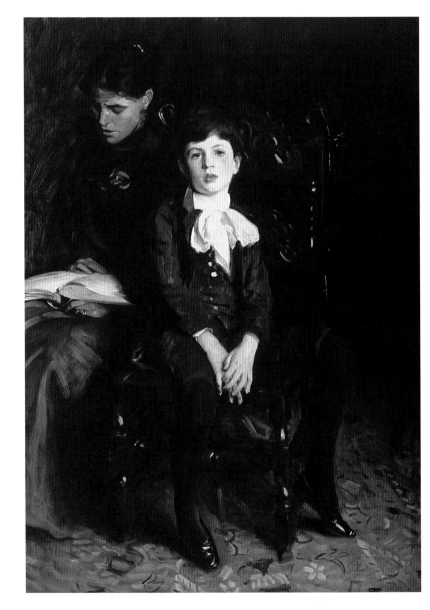

JOHN SINGER SARGENT
Portrait of a Boy (Homer Saint-Gaudens and his Mother), 1890
Sargent may have calculated that
the ungainly posture of Homer Saint-
Gaudens (the son of the famous
American sculptor Augustus Saint-
Gaudens) would give an impression
of the boy's restlessness and boredom
as he sat for the artist. Contemporary
viewers found this to be an endearing
feature of the portrait, interpreting
it as a sign of the youngster's
independence and lack of pretense.

(Front jacket)
JOHN SINGER SARGENT
Carnation, Lily, Lily, Rose, 1885–86
(detail; see page 54).

(Back jacket)
GUILLAUME DUBUFE
Madame de Beauchamp and her Children, 1895 (detail; see page 72).

(Page 2)
JAMES MCNEILL WHISTLER
The Little Rose of Lyme Regis, 1895
Whistler's sitter was eight-year-old Rosie Randall, the daughter of the mayor of Lyme Regis, a popular seaside resort in Dorset, England. The artist, who was famous for his tonal, monochromatic palettes, may have been inspired by the youngster's name in the choice of the warm, russet tones that dominate the color scheme of the work.

(Page 4)
MARY CASSATT
Portrait of Alexander J. Cassatt and His Son Robert Kelso Cassatt, 1884–85
The unity of father and son (the artist's brother and nephew) is underscored in this composition by Cassatt (American, 1844–1926), which not only reveals physical similarities and common male interest (signified by the newspaper that the two read) but also merges their figures into a single strong, dark, irregular shape. The mixture of formality (the two are close, but betray no emotion) and informality (Robert perches on the arm of the chair, his hand gently resting on his father's shoulder) suggests the emotional tenor of many well-to-do families, in which the father provided the model in whose mold the son was to be formed.

First published 2004
by Merrell Publishers Limited

Head office
42 Southwark Street
London SE1 1UN

New York office
49 West 24th Street
New York, NY 10010

www.merrellpublishers.com

PUBLISHER Hugh Merrell
EDITORIAL DIRECTOR Julian Honer
US DIRECTOR Joan Brookbank
SALES AND MARKETING DIRECTOR Emilie Amos
SALES AND MARKETING EXECUTIVE Emily Sanders
MANAGING EDITOR Anthea Snow
EDITOR Sam Wythe
DESIGN MANAGER Nicola Bailey
PRODUCTION MANAGER Michelle Draycott
DESIGN AND PRODUCTION ASSISTANT Matt Packer

Text copyright © Barbara Dayer Gallati 2004
Design and layout copyright © Merrell Publishers Limited 2004
Photographs copyright © the copyright holders; see page 95

British Library Cataloging-in-Publication Data:
Gallati, Barbara Dayer
Children of the gilded era : portraits by Sargent, Renoir, Cassatt and their contemporaries
1.Sargent, John Singer, 1856–1925 2.Renoir, Auguste, 1841–1919 3.Cassatt, Mary, 1844–1926 4.Portrait painting, American – 19th century 5.Portrait painting, European – 19th century 6.Children – Portraits
I.Title
757.5'09034

A catalog record for this book is available from the Library of Congress

ISBN 1 85894 272 1

Produced by Merrell Publishers Limited
Designed by Martin Lovelock
Managed by Iona Baird
Copy-edited by Matthew Taylor
Printed and bound in China